WHY ART

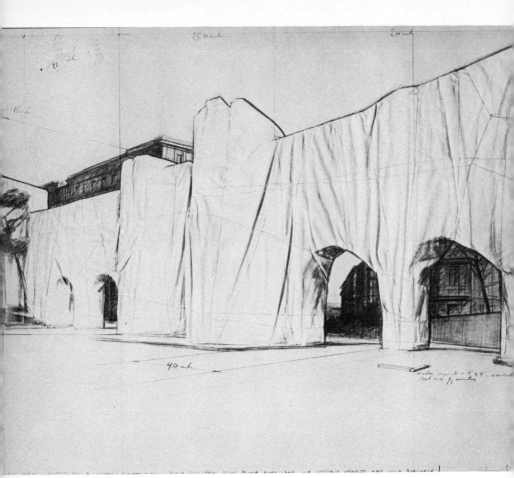

Christo: *Project for a Wrapped Roman Wall: "Porta Pinciana" Delle Mura Aureliane, Via Vittorio Veneto and Villa Borghese. 1974.* Mixed media collage. 22" x 28". "Modern art does not necessarily need to be concerned with beautification or the need to improve the existing social and cultural reality. Instead, it should perhaps widen the gap that already exists between what is and a vision of what can be."—from "Art Exhibitions and the Negation of Art." Private collection. Photograph courtesy the artist.

WHY ART

CASUAL NOTES ON THE AESTHETICS
OF THE IMMEDIATE PAST

by GREGORY BATTCOCK

A *Dutton*
Paperback

NEW YORK E. P. DUTTON & CO., INC.

Library of Congress Catalog Number: 72-122777

ISBN: 0-525-47286-X

Published simultaneously in Canada by Clarke, Irwin & Company
Limited, Toronto and Vancouver.

10 9 8 7 6 5 4 3 2 1

First Edition

Contents

GREGORY BATTCOCK is editor of several anthologies of criticism in the fine arts, including *The New Art, The New American Cinema, Minimal Art, New Ideas in Art Education,* and *Super Realism.* He teaches art history at The William Paterson College of New Jersey and New York University.

ACKNOWLEDGMENTS

Parts of this book were printed in *Art and Artists, Art in America, Arts Magazine* and *Domus: Revista de Architettura, Arredamento,* and *Arte.* I am grateful to the editors of these publications, John George, Grégoire Müller, Colin Naylor, Brian O'Doherty, Lisa Licitra Ponti, and Pierre Restany for their permission to reprint material. I wish to acknowledge help I have received from Cyril Nelson, Herbert Raymond, and Jill Siraisi.

Illustrations

WHY ART

Why Art:
Casual Notes on the Aesthetics
of the Immediate Past

WE ARE NEVER in the present; always in the past. Any attempt to understand or predict the future of art necessarily overlooks the even more baffling art of the present, which must always remain an inspiration unrealized. The critic and historian can confront art that has already been made or, at best, identify what is being made; in doing so they make that art into art of the past. Thus, it is just as reasonable to begin an essay on the art of the immediate past with, say, the screens of Ogata Korin as the paintings of New York School Abstract Expressionism.

However, there is at least one reason to choose New York Abstract Expressionism as our beginning: it is familiar and known, a language commonly understood. The reader is more likely to be familiar with works by Jackson Pollock and Clyfford Still than with Japanese screens of the Genroku era. Another more legitimate reason (the reader can, without great difficulty, familiarize himself with Oriental art) has to do with the neomorphic chronological age of Abstract Expressionist art. It is art that represents the end of an age, a time when philosophy, art, and visual conceptualization met entirely on their own happy terms, sacrificing the free will of the artist for the integrity of the discipline. It was a period of an extremely complex aesthetic morphology combined with a socially arrogant and contemptuous aesthetic elitism.

The extravagant claim, the intricate explanations, the obvious, inevitable motivations of Abstract Expressionist art prepared the

1

way for the beginning of a new and, perhaps, simpler aesthetic scheme.

The Abstract Expressionist insistence upon an exclusively philosophical as opposed to cultural or iconographical visual system left the way open for several new possibilities in artistic direction. One of these has only recently come to critical attention. I refer to the possibility of interpreting objects, both as iconographical phenomena and as useful objects, without the interference of the artist and his artistic intents. What has held back this astonishing possibility for a new style of artistic interpretation, for aesthetic stimulation without art or artistic intent?

In the main the greatest obstacle to a serious artistic (i.e. sensual and philosophical) appreciation of necessary objects produced by a technological society is the difficulty in discarding both the idea that art requires a unique, individual status and the concept of semipermanent, nondisposable consumer objects. Neither may be essential to a postexistentialist culture of individual autonomy within a sharply controlled social environment.

In art today there appears to be a willingness to consider suggestions for viewing and interpreting that are not ordinarily appropriate to art criticism. These views, in the main, grow out of the assumption that Abstract Expressionist (and Minimalist) art, by insisting on a very specific, nonobjective viewing sensorium, paved the way for today's realistic art and prepared us for a wide range of iconographical possibilities that do not necessarily depend upon formal artistic motivation.

We are beginning to question the assumption that art is the main, if not single, human phenomenon that remains constant within an ever-shifting, challenging milieu. Art too will change, and the degree of change may be so complete that art will no longer be recognizable according to the terms and standards that have been applied since the early Renaissance.

Both the classic Greco-Roman belief in art as an expression of ideal beauty and the medieval belief in art as an everyday craft of immediate decorative and spiritual value gave way to the radical Renaissance view that combines ideal beauty with social and structural (invisible) order. This Renaissance view is primarily the

contemporary view of art, and it, too, can be expected to give way to new priorities and new human, economic, and ethical realities.

The immediate ancestry of today's conceptual, realist, and disposable art lies in Abstract Expressionism, the dominant style in Western art from 1945 to 1960, in which serious efforts were made to achieve the improbable and ultimately impossible goal of completely subordinating the social and iconographic (i.e. recognizable) messages of visual art to purely aesthetic functions. Any examination of new art or indeed all contemporary visual phenomena reveals an aesthetic response largely conditioned by the unique, exclusively philosophical content of Abstract Expressionist theory.

The most beneficial effect of the style was its presupposed readiness to question aesthetic traditions; less helpful was the unfortunate willingness of Abstract Expressionist artists to dissociate "good design" from social and cultural issues. And lastly it could be assumed that if artists could safely (and quite properly) discard visual identification in favor of existential fact, then visual existential fact itself could be discarded in favor of referential image. One result would be that the image would provide the sole basis for aesthetic speculation.

No doubt the idea of art speculation being independent of artistic fact will appear somewhat revolutionary. Yet, in the sense that artistic *process* became a legitimate subject for frank and rich aesthetic appreciation, so, too, was Abstract Expressionism an authentically revolutionary school at one time. Of course, as numerous art writers have pointed out, all authentic art is to a greater or lesser degree possessed of revolutionary characteristics. Susan Sontag tell us that ". . . to be unacceptable to its audience" [1] is the characteristic aim of modern art. Gilbert Lascault writes: "The primary task of the artist is to destroy, to suppress . . ." [2] Although these factors may be said to be true of Abstract Expressionist art, nevertheless they were not of great concern to the public at large, which was generally not even aware of them.

The fact that the public was not aware of the purpose of much

[1] *Styles of Radical Will* (New York: Delta Books, 1970), p. 8.
[2] *Art and Confrontation:* ed. Jean Cassou *et al.* (New York: New York Graphic Society, 1970), p. 63.

Abstract Expressionist art activity did not concern either the artists or critics, who were not only indifferent to the absence of wide-scale popularity, but also believed that there was something basically wrong with it. Harold Rosenberg, in his widely read "primer" for Abstract Expressionist art *The Tradition of the New*,[3] wrote: "One who calls for mass communication in the arts is like a sergeant who wants to go back to good old simple drill in what our 'Defense Department' calls 'Our New Professional Army.'"

This is not to deny the importance of the aesthetic disruptions contained in Abstract Expressionist art. They were conventions in need of revision dictated by the broad philosophical developments of existential philosophy. Virtually every area of culture was similarly affected. Existentialist painting appeared to emphasize the absence of conventionally conceived meaning in art and human activity. The result was a logical, "realistic," and necessary art style of huge "empty" spaces, blobs of paint, vaguely defined shapes, and transparent overlays that, in fact, illustrated the basic mechanics of picture painting, which, after all, is what painters do. At the same time painting of this type dictated a very precise and narrow system of interpretation. There was, in fact, one central "way" of looking at and appreciating such art. Almost any kind of specific social or iconographical interpretation was intolerable. (For a thorough discussion of this problem, see Leo Steinberg's essay, "Other Criteria," in *Other Criteria* [New York: Oxford University Press, 1972].) The technical innovations and exploitations became terms in a visual lexicon of the physical realities of the art of painting. "Letters in art are letters,"[4] wrote Ad Reinhardt. Other painters referred to their art as *"It Is."* (Also the name of an Abstract Expressionist art magazine of the 1950s that was published in New York.) In short, the subject of art was artmaking; the Abstract Expressionist painters were infatuated with the objective paraphernalia of painting itself.

If the painting of the period was designed primarily for other artists, the art criticism of the period was intended for art critics, thus setting forth a new stage of art criticism penned by nonart

[3] New York: McGraw-Hill Book Co., 1965.
[4] "Writings" in *The New Art*, rev. ed., ed. Gregory Battcock (New York: Dutton Paperbacks, 1973).

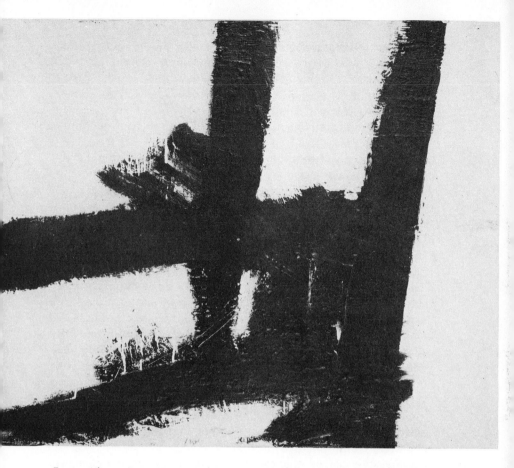

Franz Kline: *Two Horizontals.* 1954. Oil on canvas. 31⅛" x 39¼".
The Museum of Modern Art, New York (The Sidney and Harriet Janis
Collection).

critics that is already gaining increasing acceptance. Many people, including critics, assume the most interesting artwriting is that coming from the likes of Marshall McLuhan, Bob Dylan, Herbert Marcuse, John Cage, B. F. Skinner, Jean-Luc Godard, Ronald Laing, and assorted social scientists and urban theorists.

The importance of the Abstract Expressionist school of thought and its related attitudes concerning the divorce of art from entertainment, social provocation, or widespread appreciation (unlike popular music, for example, which enjoys all these) cannot be minimized.

Rightly understood, Abstract Expressionist art was not an open system drawing energy from outside areas. A misreading of the art of the period resulted in a misunderstanding of the technical innovations, and irrelevant and contradictory claims by artists and critics, despite their best intentions, compounded the confusion, which led to the uncritical perpetuation of numerous nineteenth-century myths concerning the creative process and gave rise to a distorted image of artists vis-à-vis the rest of the society. These and more misconceptions were encouraged by art exhibitions and educational institutions. Abstract Expressionist art was mistakenly identified with private emotional expressionism, in both the Romantic and Freudian senses. The implication was that artworks were mainly expressions of conscious or unconscious psychological states; pseudopsychological and mystical explanations were forthcoming, and the stylistic inventions of the school were employed in various types of supportive therapy and psychological testing programs.

If the style served the cause of psychiatric therapy, one can only say well and good. However, therapy cannot always be equated with truth, and the effect was frequently debilitating to those in the fields of education and scholarship, where it worked against authentic inquiry and the pursuit of free invention. Unfortunately, the time lag in the educational process coupled with the fact that most present art teachers, like present art critics, are of an age to have formed their ideas about art during the heyday of the Abstract Expressionist aesthetic funnel can only result in their unconscious refusal to see art in any terms other than those established for a "dead-end" system. This means that the emphases prevailing in most art courses, if not departmental art philosophies, rarely con-

sider the meaning of recent, immediately significant developments in art. Instead, prevailing theories are mostly derived from modified Abstract Expressionist concepts and, despite appearances to the contrary, from multitudinous, parasitic misconceptions thereof. In general, the art institutions in the West remain wedded to traditional methods and goals and authority; such practices are provided with a topcoating of Abstract Expressionist gloss. In short, most art agencies and art education specialists are licensed by an authority that can no longer be recognized: Abstract Expressionism.

In this book I hope to reveal several possible approaches to art and to visual communication that, in general, oppose the critical systems and interdictory criteria intended for the aesthetics of the past.

Art Exhibitions
and the Negation of Art

THE ART EXHIBITION itself remains the single most vital factor in art communication—more important perhaps than the artwork itself. Until recently, however, it has been thought of as no more than a bothersome yet necessary convention. Such an approach is inadequate in demonstrating the *positional* factor in art. The only art that seems to thrive on conventional art-exhibition techniques is negative or destructionist art, in which the main purpose of the artwork is to remove itself from existence.

Thus the *exhibition* of art is important because the *position* of the artwork—its general location, and its placement in relation to other artworks and other general phenomena—is introduced as a significant factor added to the work in exhibition and, also, because the various possibilities of negative art are introduced. The assumption is that the work is not the same seen in exhibition as it is when seen in the artist's studio, for example; additionally, negative art, or works that depend upon a reverse process or a destructive process, relies on the fact that it opposes traditional art authority, represented by exhibition formalities.

Thus Les Levine will exhibit an electronic communication device (a television set or telex perhaps); Douglas Davis will exhibit a television set facing the wall; and John Baldessari will exhibit photographs of himself destroying his Abstract Expressionist paintings. All such demonstrations enhance the exhibition process; the formal schemes of art exhibition are present as provocateurs and,

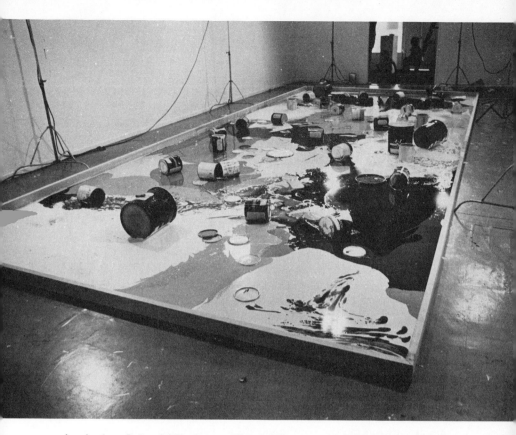

Les Levine: *Paint*. 1969. Sixty gallons of house paint and paint cans. 30′ x 14′. Photograph courtesy Molly Barnes Gallery, Los Angeles.

in effect, give the works their life and contribute to a search for new visual systems that appear to deny logic, objective thought, and common sense.

What such works mainly have in common is their antagonism to formal principles of connoisseurship and traditional aesthetics. Even the most basic visual principles, i.e. that visual art be visible, are the subject of serious artistic speculation. The common denominator of such works is their largely negative acceptance of formal aesthetic attitudes.

In a similar vein, numerous contemporary works go even further in repudiating Abstract Expressionist principles; in so doing they frequently seem to have taken suggestions right out of Abstract Expressionism itself. Basically it is the *idea* of the artwork as a temporary, deteriorating phenomenon that is new.

There is a basic, although philosophically unsound, assumption that if one accepts positive, constructive behavior in art, one must automatically believe that certain types of negative, destructive behavior are equally positive. The so-called destruction artists made their artistic point by defeating their artistic intentions. They demonstrated that in art there is no possibility of destruction that, perhaps, is not far from another and as yet undiscovered viewpoint —that there is no possibility of constructive or positive statement either.

Carrying the discussion further, Susan Sontag writes: "Contemporary art, no matter how much it has defined itself by a taste for negation, can still be analyzed as a set of assertions of a formal kind." [1] Similarly it may be claimed that the execution of a painting involves some negative activity, if for no other reason than that the white, unmarked, virgin surface of the canvas (and the wall it obscures) are victims of the painterly act. In the art of boxing the "canvas" is not permanently marked. The figures (the boxers) provide "action" on the canvas, and the action is a "time" event rather than a destructive one, in that the surface is reusable. Otherwise it would have to be permanent, like a painting. The only alternative, unacceptable to date in painting, is that the canvas be disposable. A painting, unlike a paper cup, is not yet a disposable system. In fact it would, perhaps, make better economic, ecological,

[1] *Styles of Radical Will* (New York: Delta Books, 1970), p. 31.

and intellectual sense if the painting and not the paper cup were indeed disposable.

Paint tubes are disposable. Arman has reversed that process and entombed used tubes or destroyed musical instruments in the clear lucite of his sculptures. Art that vanishes is not without precedent. The craft of the "ice carver" comes to mind—figures made for buffet tables finally (though slowly) destroy themselves by melting. Charlotte Moorman incorporates the aging process in her artwork *Ice Cello for New Jersey* (1973, a work composed by James Williams), in which she "plays" a cello of carved ice until it melts. The melting is so slow that she speeds it up with strategically placed portable heaters. Jean Tinguely, one of the first contemporary artists to illustrate the "disappearing" aspect of art, created a sculpture that looked like an Abstract Expressionist painting. That was right and proper because he was still technically working within the Abstract Expressionist sphere of influence.

The Tinguely work, *Homage to New York* (1959), was greeted as though it was a failed Abstract Expressionist artwork. In his catalogue "Dada, Surrealism and their Heritage" for The Museum of Modern Art, Curator William Rubin misunderstood Tinguely's sculpture. He wrote: "In destroying itself 'Homage to New York' fused the machine concept and the idea of Dada action in a single nihilistic event, or would have, had the mechanism not broken down short of its goal." However, according to Tinguely himself, the machine had no goal, not even complete destruction. Anything that might have happened would have been satisfactory. Tinguely's sculpture was no more nihilistic than is Nam June Paik's *One for Violin*, which was performed by cellist Moorman in New York in 1968. The climax of this silent composition results in the destruction of a violin, much to the indignation of the audience.

Clearly the distinction between positive and negative, or constructive and nihilistic, elements within art has been the subject of much recent art. It appears that the squabble is over; the solution to a dilemma originally posed by Abstract Expressionism has been found. In art all elements are positive. This conclusion is important because a major motivation in artmaking has been preempted. The new struggle may involve a search for artistic communication that, although involving the distribution of artistic in-

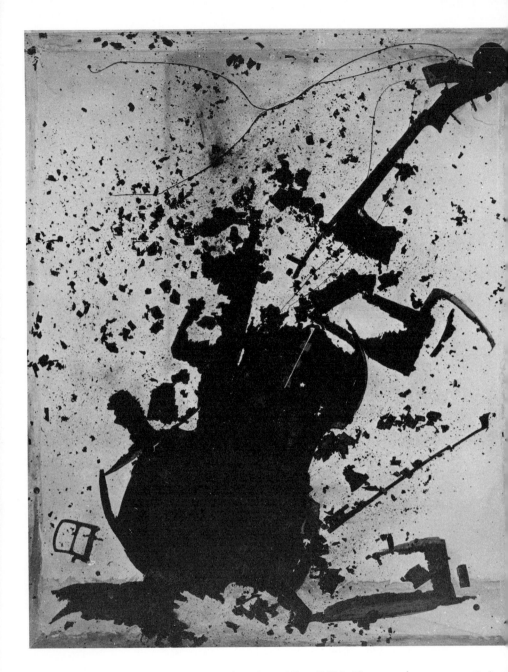

Arman: *Cimabue*. 1971. Burnt bass in Plexiglas. 6'6" x 4'4½". Photograph courtesy Galeri Sonnabend, Paris.

formation, cannot involve either making or destroying. It therefore will have to avoid process itself. It will have to occur or vanish without being made or without being destroyed or removed. The proposition appears, at this time, hopeless. However, there is evidence that it is at least being thought about.

One of the most interesting items included in Jack Burnham's "Software" show (1970) at The Jewish Museum (New York) was John Anthony Baldessari's documentation of the destruction of his own work. Baldessari, a painter, collected his entire output between 1953 and 1966 and had it all cremated. The documentation shown at The Jewish Museum included photographs of the artist's studio full of paintings, of the process of cremation, and, finally, of a neat little crematorium plaque announcing modestly: *John Anthony Baldessari, May 1953–March 1966*. The plaque and the box of ashes were actually installed at The Jewish Museum for the duration of the show.

Kynaston McShine's "Information" show (1970) at The Museum of Modern Art followed the trend that makes exhibitions into art criticism, rather than mere accumulations of works. Art, of course, turned into art criticism a long time ago and critics were left out of the picture. Now, the curators occupy roles previously assumed by the critics. "Information" went one step further. Until recently even the modern curators were content with sniffing out new trends in art and identifying them through the exhibition process. The new curator as opposed to the *old* curator (who still throws together "retrospective" exhibitions that are exercises in *art history* rather than in *art criticism*) assumes a broader responsibility that extends beyond the formal realm of art. He is more concerned with communication than with art; he is interested primarily in information processes, and his job is to try to accommodate his new concern to the traditional structure and ambiance of his medium—the art museum and the gallery.[2]

The press release for McShine's "Information" show notes:

With an art culture that has become more and more dependent on the wide dissemination of knowledge in periodicals, and one that

[2] The first such show was probably the January 1969 installation by Seth Siegelaub called "0 Objects, 0 Painters, 0 Sculptures."

"John Anthony Baldessari, May 1953–March 1966." John Baldessari in the act of destroying one of his paintings before cremating it.

has been considerably altered by communicative systems, through, for example, television, film and increased mobility, the artists try to distribute new information as easily as possible . . .

Developments along the lines indicated have already found their way into some museums and galleries,[3] but the process still has much further to go. Siegelaub's installation "0 Objects," etc., which exists only in its printed documentation, for the most part recorded projects that had been realized by the four participating artists (Robert Barry, Lawrence Weiner, Douglas Huebler, and Joseph Kosuth). However, insignificant or nearly invisible works were also included in the show.

The point of these remarks is to show that institutions devoted to the cause of art and essential to that form of communication which is art must aggressively seek out change or lose their place in the progress of modern art thought. They must take a more active part in the creation of new systems, methods, and attitudes.

The art exhibition is the single most vital factor in art communication other than the artwork itself. The approach that considers the exhibition more of a bother than a necessity is no longer adequate. It is, perhaps, redundant to emphasize that technological discovery, along with the necessity for artistic change, has rendered traditional methods of information distribution obsolete. Our search for new thought systems in art need not necessarily consider *objections* to values that appear to deny logic, objective thought, and common sense. "The struggle against common sense is the beginning of speculative thinking and the loss of everyday security is the beginning of philosophy." [4]

Specifically, McShine's and Burnham's exhibitions raise all sorts of questions that pertain directly to the process of art communication. The emphasis isn't on traditional aesthetic merit and criteria. For example, there can be no formal aesthetic analyses of the painterly qualities of the work exhibited. However, there is more to such exhibitions than a mere shift of aesthetic sights, for the works of art are still perceived within a frame of reference. In Mc-

[3] First, the John Gibson Gallery, and most recently, Terry Fugate-Willcox's Jean Freeman Gallery, both in New York City.

[4] R. W. Marks, *The Meaning of Marcuse* (New York: Ballantine Books, 1970).

Shine's case the museum is our frame of reference for the artworks; it interacts with them in providing the meaning and the information that the observer expects to receive. The problem concerning frame of reference is quite new. One aspect of it may be said to have been introduced to art by the serial artists, including Robert Smithson, Sol LeWitt, and Charles Ross, who have presented works in serial form with each element depending on its reference to other elements for meaning.

The problem also exists in a somewhat different, larger area, for in the widest meaning it is the frame of reference that identifies and gives meaning to any art document, and without it the document is invisible and quite useless. The gallery or museum is one frame of reference for art; a book or a catalogue can be another.

Art statements, documentations, illustrations, and proposals are frequently given their meaning by the location in which they are found. Something seen on a wall at The Museum of Modern Art would have an entirely different meaning (if any at all) if it were found on an empty seat of the IRT subway. Without special location and the frame of reference thereby supplied, many artworks would be totally meaningless. In effect, they would cease to exist as art.

Thus one result of the new concept *frame of reference* is that artworks have to be made specifically *for* The Museum of Modern Art or some other institution. But there is also the possibility of a negative confrontation with such a frame of reference. If one appreciates the power of positive action in art, one must automatically believe that certain actions are negative—otherwise there could be no positive in the first place. However, if we advance the idea and state that, in art, there is *no such thing* as a negative action, we would then be liberated from the restrictions implied by a reliance on positive thought and behavior. The so-called destruction artists made their point by defeating their artistic intentions. They demonstrated that in art there is no such thing as authentic destruction. All art involves some destruction.[5] In fact (and this is a point advanced by Herbert Marcuse), the negative aspects could, with advantage, be further emphasized in many instances. One type of

[5] Jose Ortiz has killed chickens and Arman has destroyed objects, and they have declared these acts to be art.

negation in art exists within the very concept of beauty, not that art has any particular obligation to be beautiful. Modern art does not necessarily need to be concerned with beautification or the need to improve the existing social and cultural reality. Instead, it should perhaps widen the gap that already exists between what is and a vision of what can be.

Wall Paintings and the Wall

Despite the apparent remoteness of painting from social and political issues (the only issues that really matter), new developments in art are indeed related to significant changes in visual communication. Therein lies their importance. Some recent discoveries in art are important mainly because they call attention to issues that have been obscured by six centuries of aesthetic inbreeding. Otherwise, they are not especially new. However, there are a few truly original discoveries of tremendous importance. I hope to identify those, too.

The "peaceful" revolution that Charles Reich identified in *The Greening of America* is not confined to consciousness, yet that is what it is all about. Marcuse was right in criticizing Reich for offering a "peaceful" revolution in the first place. However, violence, as a communicative procedure that effects change, is subject, as are all such procedures, to sheer exhaustion. As a communicative idiom, painting is exhausted. Art is the abstract *distribution of information*. The problem lies in the *distribution*. That is the core of the issue. In general, painting is not capable of efficient, intelligible *distribution*. Modern packaging technology—in consumerism, in advertising, in policies, in art, in revolution, and in communications—is mostly a *science for distribution*. Art remains different from the design for dishwashing-liquid containers because it remains abstract, artificial. Tangible material is not, in art, the content, but merely a vehicle. *Distribution* is mainly effectiveness in attracting

consciousness and energizing it. Nowadays communications are only good when they are able to effect a *change in consciousness.* And communication is subservient to *distribution.*

Significant communication provokes traditional values because virtually all traditional values are tyrannical. Chivalry is also male chauvinism: therein lies the tyranny of chivalry. The tyranny of glamour is sexism. Art, like practically everything else, is also tyrannical. If the art of painting is to resume a significant place in the realm of visual communication (which is not necessarily essential or even desirable), its tyrannies need to be discovered and identified. Efforts to expose the tyrannies of the fine art of painting are the major motivation for several recent developments in the field.

An exposé of the tyrannies of painting will not be exciting reading. It will involve, primarily, an interesting awareness concerning the distinction between painting and other visual forms. How does painting differ from mosaic, or fresco art? From ceiling painting? The last can be dismissed easily. The viewer cannot normally adjust the distance between himself and the ceiling, whereas he can regulate the space between himself and the "wall" painting. That "distance" is very important. How often have we decided to "step back a bit" when looking at a wall painting?

I will confine my observations to wall painting. Within this area, numerous recent discoveries tell us that there is a great deal more to visual communication than meets the eye.

Let's consider, briefly, what painting is. Post-medieval painting is primarily a flat idiom that *contains* its own surface and that at the same time *obscures* another surface—that of the *wall.* The wall is a *condition* for painting—as important as the frame (or edge), for example, or the paint itself. However, painting (as we know it) *obscures* the wall, and therefore can be read as a *repressive* medium because it subjugates another surface—that of the wall itself. If it subjugates the wall, at least that means the wall *exists.* We can think of visual forms similar to painting that do not even permit the separate *existence* of the wall. Nevertheless, the point is that the wall that is obstructed possesses communicative potential.

As far as we know, the earliest forms of painting involved "paint" applied to a surface directly, as in cave paintings, or

frescoes. The texture of the original surface was not necessarily concealed, and it assumed an active responsibility in the communicative language. Also, in mosaic and fresco painting, the wall and the painting are one and the same object because there *is no space between* the fresco and the wall or the mosaic and the wall. Painting, then, differs from these other flat visual forms in that a painting has a *front* and a *back,* thereby indicating that there is *space between the painting and the wall.* In certain recent art, that space has been appreciated and incorporated into the subject of the works.

In 1967 William Anastasi offered paintings that seemed to acknowledge the obtrusive nature of painting by making paintings of the walls that the paintings were to be placed upon. Thus the "covered up" area—the area that traditionally suffers at the expense of the imperialism of painting—was acknowledged to exist and actually illustrated (via photographic technique). Fortunately the wall was flat, so the problem of the hypocritical illustration upon a flat surface (the canvas) of a three-dimensional object was avoided. In these paintings one tyranny of painting was discovered. The form of painting took a giant step into the present.

Frank Stella is rightly admired for recalling another condition of painting that had become all but obscured during the centuries of "fine art." He rediscovered the importance of shape and, in so doing, reminded us that many centuries ago virtually all "paintings" involved manipulation of shape. Such paintings weren't always square or rectangular. As a matter of fact, the forefathers of the modern art of painting, in thirteenth-century Siena, created elaborately shaped surfaces that were frequently in the form of crosses and that corresponded to the subject, which was, as often as not, the Crucifixion of Christ. Both Stella and Jasper Johns demonstrated that the most appropriate subject for illustration upon a flat surface was something flat—a target or a flag, for example. Flatness was thus recognized as a condition for painting. Also such flat objects that were represented were frequently of fixed shape (rectangular flag on rectangular surface), freeing the artist from the responsibility of determining shape upon canvas. We are reminded that the shape of the crucifixion was also fixed—more so than the shape of the *painting on* the crucifixion.

Anastasi: *North Wall, Dwan Main Gallery.* 1967. Oil on canvas. 7'1½" x 7'¾". Photograph courtesy Dwan Gallery, New York.

A crucifix is flat and in the shape of a cross. A primitive Sienese painting of a crucifixion is also flat and possesses the shape of a cross. In Jack Velez's *Star* (1971) the "fixed" image of a star is painted upon a square surface. However, the star itself is encircled, and the gap between the "fixed" shape of the star and the "fixed" shape of the square surface is bridged.

Anastasi is concerned with the surface that the painting obscures. He overcomes the problem of "space" between the painting and the wall. Stella is concerned with the shape of the image, which corresponds to the shape of the object. Johns dispenses with the contradiction between depth illusion and "real" flatness. Velez accommodates a depicted shape upon a contradicting "real" shape. All four painters refer to the roots of pre-Renaissance painting and rediscover issues that were pertinent to the origins of painting, which had to be rediscovered in order to clear up the aesthetic tyrannies that make up our modern art heritage. In speaking of late Byzantine painting, Lionello Venturi pointed out that "the figure gradually dwindled down into the symbol."

The problems cited above refer to yet another aspect of painting —the back. Early Christian artists in the visual arts made mosaic pictures or frescoes which, in technique, were very similar [1] and that became, in fact, part of the wall. Obviously they had only one side—the front. The primitive Sienese painter, emerging from the Spoleto or Umbrian "school," painted on wooden (or canvas) panels that were flat but, unlike the walls used by the mosaicist or fresco painter, were movable. Therefore they had to contain *two sides*.

Thus the primitive crucifixion painting is flat and shaped, yet has both a front and a back, but only the *front* was painted. However, the back side was there and could *even be seen* (even though there wasn't much to see), because the crucifixion was sometimes

[1] Rosabianca Skira-Venturi (and Lionello Venturi), *Italian Painting* (Geneva and Paris: Skira, 1950), p. 22: "Despite their different chromatic values, the techniques of the mosaicist and the fresco painter are very similar. Indeed, quite often a preliminary layout in fresco served the former as the basis for his decoration in mosaic. It should, however, be noted that when the workers in mosaic tried to adapt their technique to effects more suited to the fresco, their work lost its originality and fell short of the high artistic standard they attained when they kept in view the requirements of their own *métier*.)"

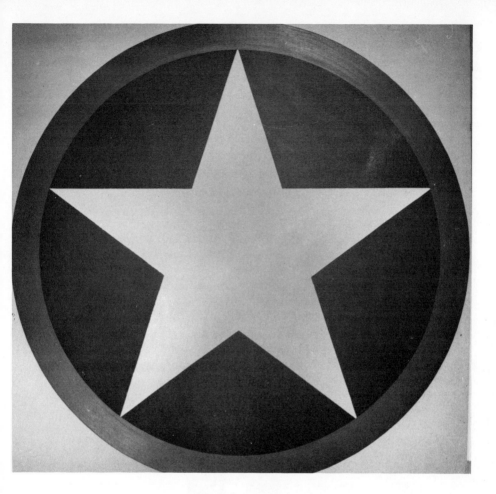

Jack Velez: *Star: Red, White, and Blue.* 1970. Acrylic on canvas. 48" x 48".

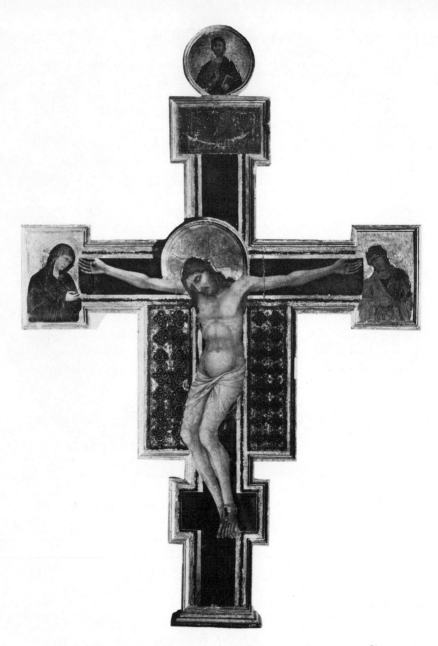

School of Duccio: *Crucifixion*. Early 14th century. Pinacoteca, Siena.

designed to stand *free from the wall*—there being a space between the painting and the wall.

The painting of the crucifixion "stood" the way a real crucifixion might. Therefore we can surmise that one difference between a "painting" in the modern sense, and a fresco or mosaic picture, is that there is a *space* between the painting and the requisite wall. Both pictorial forms, however, depend upon the wall. Sculptures by John McCracken seem to provoke this point. His flat panels lean upon the wall, yet we can *see* the space between them and the wall. Also their monochrome color is identical both *front and back*—visually, then, the back of the panel is just as interesting as the front—or at least, not any *less* interesting. McCracken's works share something else in common with primitive Sienese crucifixions —they both depend upon the floor for support and thus are inter-disciplinary documents.[2]

The fact that paintings have a back side that is there and that is a condition of painting is a virtually unexplored phenomenon. The primitive crucifixion referred to above came close to exploiting this condition by standing free of the wall. Several recent developments indicate that the *back side* of the painting has been noticed by artists.

That the back of the picture is not necessarily seen is not important. Artists have already demonstrated that visual art doesn't have to be visual anyway. Such demonstrations have occurred in degrees, and artists such as Ad Reinhardt, Ellsworth Kelly, and the conceptualists have amply illustrated the dilemma, which is, briefly, that we don't exactly know what the *visual* in visual art means.[3]

[2] The floor as communicative surface in an environment of limited empty spaces has been acknowledged by several modern artists. Ellsworth Kelly extended the painting from the wall down onto the floor, yet retained "rights" to the space *above* (*White Angle*, 1966). Carl Andre removed the painting from the wall and from painting and brought it into sculpture and onto the ground. By contrast, he did not "claim" the space above, and one can walk on his "sculpture." The implications of Andre's works are misunderstood by almost everybody, including, I am beginning to think, by Andre himself. In his notes on Andre's Guggenheim Museum exhibition, Grégoire Müller (*Arts*, November 1970) came close when he stated, "Horizontality is for Carl Andre an almost ethical limitation . . ." It is that, and much more. It is a communicative idiom and a new definition for a sculpture that need not *displace* space.

[3] Les Levine has made a movie for the blind. (*Blank*, 1970. 45 minutes. 16 mm.)

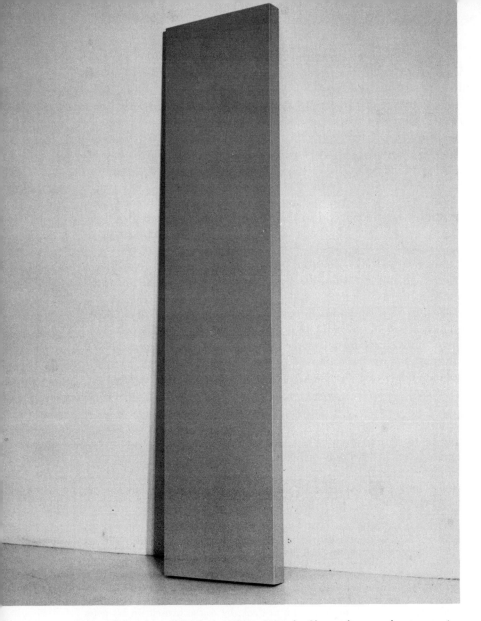

John McCracken: Untitled. 1970. Wood, fiber glass, polyester resin.
8' x 22" x 3⅛". Photograph courtesy Sonnabend Gallery, New York.

Roy Lichtenstein: *Stretcher Frame with Cross Bars.* 1967. Oil and Magna on canvas. 48" x 60". Collection of Philip Johnson. Photograph courtesy Leo Castelli Gallery, New York.

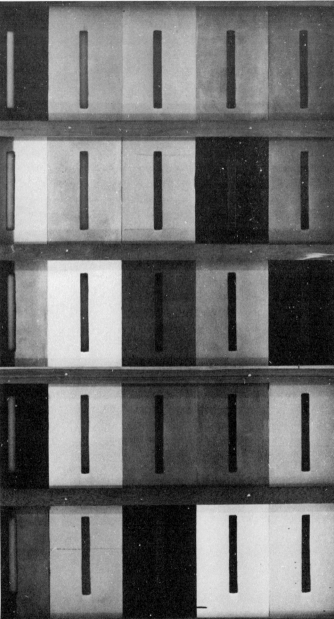

James DeFrance: Untitled (Rear View). 1970. 48" x 84". Acrylic on canvas. Photograph courtesy Sonnabend Gallery, New York.

Recent creations by artists involving the back of the canvas run the gamut from totally visible pictorial representations of the back *on the front* by Roy Lichtenstein (1967) to unseen (but experienceable) *rear-of-the-picture* painting by James DeFrance (1970). DeFrance cuts holes in the surface of the canvas, allowing in light, which reflects off the wall (behind the painting) and onto the *back* of the painting, which is painted. The color re-reflects onto the wall, and the viewer sees the wall and the *reflected* color. After this, discussion of "real" versus "depicted" shape appears decidedly old-fashioned, though discussion concerning "real" versus "reflected" color is equally academic.

The front surfaces of DeFrance's pictures are monochrome, and the holes provide the only variation. One's attention is directed to the holes (where the "energy" of the work is contained), and the space between the painting and the wall, besides the back of the picture itself, is the "subject" of the work. Some observers may find the "back" of the picture of greater visual interest than the front, since all the painting is there. Thus DeFrance, unlike Lichtenstein, actually paints the back and, unlike McCracken, sees to it that the back is different from the front, if not more interesting. Yet, as pointed out above, that isn't the issue. At this point the reader might well ask, just what is the issue?

I'm not sure I know. Somebody will point out that DeFrance merely repeats the "slashes" of Lucio Fontana, but that's not the case. Fontana did not, as far as I know, paint the backs of his pictures, and one couldn't actually look through the slashes. The wall in back was not visible, and the backs of Fontana's pictures did not assume an active role.

The Art Critic as
Social Reformer
–With a Question Mark

ACCORDING TO HERBERT MARCUSE, mid-twentieth-century technology has given mankind its first opportunity for true freedom. But this freedom cannot be achieved unless men can be induced to abandon their traditional ambitions, goals, competitions, classes, priorities, drives, and hates, all of which were encouraged by the requirements of the old production-possession-consumption economic organization. Several contemporary developments in art can be said to attempt to apply such logic to artmaking and art institutions. The Guerrilla Art Action Group of Jean Toche and Jon Hendricks is one example. Another is the Artists' Reserved Rights "contract" proposed by Seth Siegelaub in 1972. A major step was the formation of the Art Workers' Coalition, and the Artists' Open Hearings it sponsored in 1969. However, the art-world figure who came closest to introducing advanced social theories to real contemporary art-world situations was the critic Gene Swenson.

Gene Swenson was killed in an auto wreck in Kansas in August 1969 at the age of thirty-five. Well before then he had become the most controversial and talked about art writer of his generation. Swenson had attempted to bring contemporary art into the mainstream of social and political protest. He saw art and art criticism as a vehicle for improving the lot and the awareness of man. His actions first became gossip, then legend: his visit to the United Nations to obtain international citizenship, his shouting matches

with art dealers and publishers, his picketing of The Museum of
Modern Art in the winter of 1968/69 carrying a huge question mark.
He had been in and out of Bellevue and many thought him crazy.
But he was articulate and implacable in his efforts to remind artists
and intellectuals of their social and political responsibilities. "In
these times," he wrote toward the end of the sixties, "when so many
are suffering so much, can we not spend a little more time sharing
in their suffering; that might affect our art, which in turn could
affect men's hearts and souls (I'm not advocating Social Realism,
although what could be more hollow than Neo-Modern?) . . ."

As his writing became radicalized, it also took on a deliberately
anti-intellectual and folksy tone.[1] In a letter to *Arts Magazine* in
1969, signed "Gene 'Kansas' Swenson" he wrote:

I'm just a simple country boy from Kansas. I take everything kind
of personally . . . Jackson Pollock must have been quite a guy. A
real artist . . . I came to New York and learned a lot from these
Eastern intellectuals. I think I understand all that stuff they write
about Pollock, the way the skeins relate to the picture plane, the
way the cutouts were a real step forward . . . all that stuff. I'm
sure Pollock would have appreciated it, too, even if he did come
from Wyoming.

People tell me Pollock was a little uncouth, it came out especially
when he got drunk. And they say he wore cowboy boots and tried
to look Western—even though everybody knew he was pictorially
sophisticated. Anyway, I got this image and then I looked at all
those high-falutin' classical subjects and you know what I wanted
to say to him? 'Pasiphaë my ass. Come off it, Jackson.' Now I know
I must be wrong. So much has been written by those people who
are much more intellectual than I am and people who have degrees
and know art history better than me . . .

He deliberately ridicules the postures of official art writing by in-
cluding small-town rural dialect:

Anyway, here I was going along in the Pollock show and I came to
those big drip paintings. Golly Moses! Well that's not saying much

[1] Thus Swenson deliberately exploited popular anti-intellectualism of the
sort Marcuse writes about when he observes: "The common denominator for
the misplaced radicalism in the cultural revolution is the anti-intellectualism
which it shares with most reactionary representatives of the establishment."
H. Marcuse, *Counterrevolution and Revolt* (Boston: Beacon Press, 1972).

'cause I guess anybody with an ounce of feeling feels that way now. The only thing I couldn't understand was where are the seashells and the cigarette butts and . . . God damn—they'd cleaned him up. Artified him. Post-malerisch or something . . . Now I know you're all going to think I'm crazy, but I'm telling you what happened to me and I'd just be lying if I left it out.

Perhaps it was his dealings with The Museum of Modern Art, for which he organized an exhibition called "Art in the Mirror" in 1967, that focused his attention on art museums and their effect on broader social and cultural issues. It wasn't long before Swenson dared to link up the management of the museum with American foreign policy and the Vietnam war. In 1968 he became something of a latter-day Diogenes by picketing the museum every day from eleven to two for a period of several weeks while carrying, for a sign, a large question mark. He was thus the first art-world personality to protest publicly the policies and administration of the museum—protests that were revived on a broad scale by the Art Workers' Coalition in 1969 and 1970, and that ultimately brought about some reforms.

At one point Swenson issued a printed statement announcing he would perform an "act of melodrama" at the museum. He arrived at an opening dressed in a paper vest bearing the words "Virtue Is Its Own Reward," and carrying a beggar's tin cup. He intended his gesture to illustrate the "intellectual poverty" of the art world. And in his view, his question mark was the ultimate symbol of the existential dilemma—everything is a question and *in* question. When someone suggested that he had merely bent Barnett Newman's stripe into the form of a question mark, Swenson, who liked Newman's work, agreed. Neither Swenson nor his picketing was as crazy as everyone thought at the time, and he was one of the first to introduce poetry and style into contemporary political and cultural protest.

Swenson's gestures, writings, and political stance confused and alarmed many people. His challenges to respected art-world figures (Thomas Hoving, Clement Greenberg, and Henry Geldzahler), his linking of the prestigious Castelli Gallery with capitalist exploitation, his attacks on The Museum of Modern Art—all identified targets that had hitherto been immune from social and political

scrutiny. It was a time when people were unwilling to believe that the prevailing artistic scene was indeed a product of a larger imperialistic system. In bringing social, economic, and moral issues to bear in the marketplace, Swenson hoped to reform a situation in which advanced art had by default aligned itself with the forces that it had traditionally held in contempt.

Though eventually he had difficulty in publishing his work, Swenson continued to articulate his ideas. A number of his essays appeared in the now defunct *New York Free Press.* "An Art Critic's Farewell Address" (1968) is a curious, sensitive document that isn't really a farewell address at all, but another plea for ethical reevaluation of modern aesthetics, containing "personal" experiences that were anathema to the orthodoxies of current art writing. His last published piece, "From the International Liberation Front," was printed in the Art Workers' Coalition "Open Hearing" volume in 1969. It is a manifesto touching on art, politics, the war in Asia, and revolution. When he rose to read the document at the historic Open Hearing at the School of Visual Arts on April 10, 1969, Swenson was still working on it. He began mildly enough: "We meet tonight, not for us alone. We wish to change politics, so that the tyranny reflected in the institutions of this nation at the present moment can never again oppress us." He finished his introduction with the words "The revolution we seek is no more—and no less— than to tell the truth." This brought down the house. Increasingly excited by his own words and their effect, he strayed from his prepared notes, and went on with amazing confidence and showmanship. Unfortunately his extemporaneous remarks are not preserved.

But the next paragraph of the prepared manuscript touched some original material that, alas, has never been developed and that could have been a major interpretation of the role of art in times of crisis. He introduced the idea that established culture was something of a police agency itself:

> The innovation and training of sensual appetites, which is the traditional concern of artists, seems a frivolity to most citizens (as it seemed to Plato), for politics seeks to subdue those conflicting appetites which are the very meat of art . . . The tyranny of military requirements reveals itself slowly, at first in traces of conversations,

in aesthetic theories which detach the spirit of the times from the (art) events. Tyranny even begins to creep through the studio doors as the artist sits alone, until fear of a police inspector (be he from the 5th precinct or the Guggenheim Foundation) paralyzes those senses essential to guide the artist's voyage of discovery.

Art institutions, he added, "have become positive weapons, a cultural ABM, of that tyranny which now oppresses all mankind with its balance of terror." And seeking to unlock the radical energies of art past and present from the prisons of history and scholarship, he went on to say:

We wish to learn from the art which our spiritual ancestors have left us, not those footnoted lessons of establishment catalogues and magazines, which turn the spirit to cliché and cliché to credibility gap; we should learn those rituals which liberate the soul, those lessons which turn a collective past into the free man, which turn individuality into supreme fiction.

Swenson's large and passionately held reformist views give his own singlehanded attempts to accomplish them a degree of pathos. Yet his brief career was exemplary in its pursuit of them at any cost—and the cost in friends, stability, and financial security was great. When Swenson died, many of us felt as though we had lost our conscience.

Herbert Marcuse

THE DISINTEGRATION OF formal[1] artistic criteria cannot be said to have begun in earnest until the mid-nineteen sixties, coinciding with the waning of the Abstract Expressionist and Minimal schools. Despite their drama and, frequently, sweeping gestures of painterly negation, both Abstract Expressionism and Minimalism mainly accepted and reinforced traditional criteria. They owe their content and direction to serious, historical recognition of the artistic principles developed during seven hundred years of Western art. Frequently both movements sought justification and license in the scholarship of traditional aesthetics.

The post-pop and conceptual-political artists of the late sixties and seventies assumed a genuinely radical aesthetic orientation that denied the very principles of connoisseurship itself. Even the visibility concept—that visual art should be seen—as well as the idea of art as object that exists, was no longer an automatic assumption. And just as Clement Greenberg became the major aesthetic definer of Abstract Expressionist and Minimal Art, we discover that a *political* philosopher, Herbert Marcuse, became the major *aesthetic* definer of a new kind of art.[2]

[1] In reference to hand-painted, describable, portable objects.

[2] Marcuse is mainly concerned with the "fine" arts in his recent writings on art, particularly those portions of *An Essay on Liberation* (1969), *On The Future of Art* (1970), and *Counterrevolution and Revolt* (1972) dealing with aesthetics and artistic sensibility. His thoughts on the popular forms would,

Marcuse raises a number of interesting questions and challenges many assumptions about art. For example, he notes that society demands that art be beautiful: that it transform the chaos of actuality into the orderliness of art and so create a refuge for the mind. However, in such a situation would not creativity become a servant of what *is*, rather than a discoverer of what might be? Art then, according to Marcuse, operates to reconcile men to their social fate instead of rousing them to change it.

Of course a new kind of art requires critical facilities receptive to it. Yet the existing facilities of man have been distorted somewhat by the repressive and aggressive nature of present society. Marcuse thinks that the proper role for the artist is to reshape the imagination of man, and by doing so awaken new critical faculties more appropriate to a new social emphasis. Marcuse would see art ". . . become productive force in the material as well as cultural transformation . . . shaping the quality and the appearance of things . . . the way of life." However, Marcuse explains that art can become a truly productive force with the ". . . end of the segregation of the aesthetic from the real . . ." and, presumably, this would mean the end of the distinctions between aesthetic criteria and the quality of life.

This view would seem to contribute to the validity of art as a disruptive phenomenon. In fact Barbara Rose has described the radical aesthetic of John Cage in the following terms: "For Cage the radicality of art is defined not in terms of its form, but in terms of its disruptive function within a given social, political, economic or psychological framework." [3]

A kind of art that is likely to be immediately disruptive is a

no doubt, make interesting reading. He observes, for example, that the standardization of obscene language ". . . turns easily into sexuality itself" (which, while not necessarily true, is a provocative thought). He goes on to point out a most realistic dilemma in language: "If a radical says 'fuck Nixon,' he associates the word for the highest genital gratification with the highest representative of the oppressive Establishment." In this same vein Marcuse observes that the radical who uses the word *shit* for the products of the establishment in effect assumes ". . . the bourgeois rejection of anal eroticism." Such delightful applications of Freudian and Marxist conceptualism to contemporary "counterculture" patterns is fascinating, and one longs for more. (All quotations from *Counterrevolution and Revolt* [Boston: Beacon Press, 1972]).

[3] Barbara Rose, "Politics of Art," *Artforum* (1969).

kind of art that is not usually considered art in the first place. Marcuse has offered one specific example of such art. In a lecture at the Guggenheim Museum [4] he labeled the revolutionary graffiti painted on the walls of Paris during the 1968 May rebellion as "anti-art" because they were entirely spontaneous and, although visual and pictorial, were not conceived with any deliberate artistic intent. Thus art that is deliberately intended as art may necessarily be a type of expression that, for the time being, is not entirely reasonable.

Art as commodity, as marketable object, has been rejected, to a greater or lesser degree, by a good many of the earth, conceptual, and process artists. It appears that part of the reason lies in a general dissastifaction with the crude mechanics of the larger part of capitalist economic and social organization. Marcuse pointed out the basic antagonisms between effective art and capitalism before many artists reached similar conclusions. He warned that "Capitalist progress . . . not only reduces the environment of freedom, the 'open space' of the human existence, but also the 'longing,' the need for such an environment." He goes on ". . . quantitative progress militates against qualitative change even as the institutional barriers against radical education are surmounted." [5]

Although the tendency to construct works that are nonmarketable will surely fade away, its very presence as an active aesthetic determinant is worth noting. Those who defy the notion of art as a marketable item seem to reinforce Marcuse's pronouncements [6]:

[4] In *On The Future of Art* (New York: Viking Compass, 1970).

[5] *An Essay on Liberation* (Boston: Beacon Press, 1969).

[6] Even the best efforts on the part of the artists to avoid the commodity market in their art can only be partially successful. Records of *proposed* artistic activity remain in unique form as plans, notes, photographs, and reviews. Some of these documents become salable objects. Moreover, the artists often received indirect remuneration in the form of professional recognition, which can lead to personal profit. Such popular forms as prints and multiples are not generally considered authentic denials of artwork-as-unique-commodity. Jean Cassou writes: "The multiple is the democratization of art as against the socialization of art. It is reform as against revolution." (*Art and Confrontation* [New York Graphic Society, 1970] p. 25). He also remarks: ". . . multiples under their existing copyrights only seem to act as a cloak for a particularly astute commercial operation" (p. 52). Raymonde Moulin offers a more optimistic view of the phenomenon: ". . . the invention of multiples seemed bound to lead to radical transformation of the social and economic

Even the art market, as any other ". . . has always been one of ex-
ploitation and thereby domination, insuring the class structure of
society." [7] The reasons for Marcuse's attitude are obvious. He him-
self points out:

> The so-called consumer economy and the politics of corporate capi-
> talism have created a second nature of man which ties him libidinally
> and aggressively to the commodity form.[8]

Such remarks, as effective as they may be in driving people to look
at situations in a highly critical way, will not necessarily remain
valid. The artist motivated by them will, in time, reject them. Al-
ready their political and social implications are being questioned.
For example, although it may be possible to define a northern urban
industrial worker with a house, a mortgage, a car, time payments
on the car, a washing machine, time payments on the washing
machine, a color television set, and time payments on the television,
as oppressed—as he certainly is enslaved—is he more or less op-
pressed than, say, an economically redundant sharecropper in
Georgia or a welfare mother in Bedford-Stuyvesant? Certainly
most of the American poor, who presumably have had more experi-
ence of oppression than any philosopher, would settle quite cheer-
fully for the evils of consumerism if they had the choice. What is
true is that the quality of life in advanced industrial societies is
abysmally low. But then, one suspects that it always has been,
except for the privileged few. This is not an argument against the
need for change; but to identify consumerism as the permanent
enemy is to come perilously close to the condition of the self-suffi-
cient peasant farmer, and from some aspects that does not seem
much more a solution than the back-to-the-land panacea of com-
munal families.

status of the work of art. Once we admit that the concept of the multiple
implies the utilization of industrial techniques as a means of creation and not
of reproduction, the elimination of the original, and the manufacture in series
of identical, interchangeable objects, abundance replaces rarity and works of
art thus lose both their exceptional dignity and their quality as extraordinary
economic goods" (pp. 127, 128).
 [7] *An Essay on Liberation.*
 [8] *Ibid.*

Marcuse predicts the inevitable collapse of typical middle-class culture, thus ensuring a change in the kind of art that culture produces. Already outdated, such culture will be destroyed not by student rebellions or the new life-style movements as many had hoped, but, surprisingly, by capitalism itself "which made this culture incompatible with the requirements of its survival and growth." [9] Marcuse cites, as evidence of the decline of the bourgeois culture, the paradox of the need by the ruling class to perpetuate a "consumer" society while remaining dependent upon alienated labor. (This point may appear outdated to some, who may question the validity of the alienated labor concept.) Nevertheless the dilemma so far stated is simply: if capitalism requires the overthrow of bourgeois culture, is not the cultural "revolution" defeating its own purpose by aiding capitalism rather than seriously provoking it? The contradiction stated above is, according to Marcuse, reflected in contemporary efforts to develop "anti-art" and "living" art forms. Essentially, such forms serve to unite the intellectual with the material culture, from which he has traditionally been separated.

There is another art, a "bourgeois art", which is not the same as higher intellectual art. Bourgeois artworks may be commodities, yet Marcuse grants they represent authentic works. They possess class content ("the bourgeois, his decor and his problems dominate the scene") whereas the higher culture (of the bourgeois period) is an elite culture "available and even meaningful to a privileged minority." [10]

The answer to this clearly undemocratic state of affairs is not to be found within the cultural revolution, which "aims far beyond the bourgeois culture . . . it is directed against the aesthetic form as such." [11] Marcuse chooses to defend aesthetic form because it contains "anti-bourgeois qualities" and he claims that one task of the cultural revolution is to capture and transform such qualities. Briefly, the major arguments against aesthetic form are that it "is not adequately expressive of the real human condition," that "it is divorced from reality," and that basically it is a "factor of stabilization in the repressive society." There is no need to question these

[9] *Counterrevolution and Revolt* (Boston: Beacon Press, 1972).
[10] *Ibid.*
[11] *Ibid.*

elementary, frequently stated arguments, although more could be added to the list. One could point out, for example, that aesthetic form itself is essentially a "Christian" notion that requires "non-aesthetic" form; that it requires refined (i.e. aesthetic) activity to remain distinct from work ethics; and, lastly, that it elevates art and artist to a ridiculous and altogether improper position (vis-à-vis the rest of the culture), which is both obsolete and hypocritical. There is little doubt but that contemporary culture is suspicious of the aesthetic form and its links with capitalist notions of "progress." It will not suffice to claim that aesthetic form contains "anti-bourgeois qualities" or to insist upon an intrinsic subversive nature of art. At any rate it is, at best, a limited subversion because, as Marcuse points out, ". . . art . . . cannot change reality . . . cannot submit to the actual requirements of the revolution without denying itself." Such a belief falls firmly within the mainstream of twentieth-century aesthetic thought; it is neither capitalistic nor socialistic but, rather, commonly accepted by artists of all political persuasions. There are those, however, who question whether this "aesthetic law" cannot, at least in some ways, be slightly bent.

In art, as in culture, the reaction against consumerism can be expected to develop in various directions. There will, no doubt, be a return, in art at least, to some values currently under attack; the work of the Super Realists is but one example. Yet a definition of quality is hard to pinpoint. Thus, if the major goal is quality, then it is an elusive goal. Paul Goodman has been quoted as follows: "Stop talking about the quality of life. Leave the quality of life to poets and lovers. Keep government planning to the minimum level of the tolerable. Give the people bread and let them make their own circuses." [12]

The major and, perhaps, most desirable change that could occur in art would depend, mostly, upon what happens outside of art. Such change would force art out of its special category, i.e. a phenomenon *more* desirable than any other. Art would cease to represent a break in the daily routine of living by presentation of something "higher" or "truer." Its present function is to provide what Marcuse terms a "holiday of the soul," but it does not change

[12] *International Herald Tribune* (Paris), September 2, 1970.

the behavior of man except for the short period in which one is actually in contact with art. During that period art confronts man with the beautiful and the sublime in ways that are not part of the normal routine of living; it provides him with a short period of respite and elevation. But to this limited extent it may serve to alienate him from existing society by opening out other views. Art then can perform two apparently contradictory functions. It both sustains the established culture by making it bearable and providing a holiday from it and undermines the culture by serving as an agent of alienation. Art then assumes both negative and supportive roles—however, should the need for the long negation of the supportive role diminish, the entire form of art would necessarily shift.

One may ask what rules govern the organization of art that both serves and provokes the established society. Marcuse claims that traditionally the common denominator has been the idea of the beautiful, a definition that is not nearly so acceptable today as it once was. For example, Susan Sontag observes that as far as "beauty" in art is concerned, "Modern aesthetics is crippled by its dependence upon this essentially vacant concept. As if art were 'about' beauty, as science is 'about' truth." [13] The concept is, of course, traceable to Marcel Duchamp and Dada. The idea of the beautiful is frequently in conflict with art's cognitive function to be true also. Nevertheless, to pursue the point a bit further, once reality, no matter how revolting, is organized in the form of art, it succumbs to the idea of the beautiful. In Marcuse's words, "The artist indicts—but the indictment anaesthetizes the terror."

Considered in this light, it now seems "that the commitment of art to the ideal, to the beautiful . . . offend[s] the human condition." Thus, once again, we are given reason to imagine an artistic rebellion against art, against the very form of art. It is also reasonable to assume that the changing human condition itself will alter the nature of its responses.

Marcuse has anticipated such a change. It will accompany the creation of a "revolutionary" society. However, what is authentically revolutionary in one time and place is not necessarily truly revo-

[13] Susan Sontag, *Styles of Radical Will* (New York: Delta Books, 1970), p. 30.

lutionary under different circumstances. Revolution is not a textbook phenomenon. The form of art can be changed according to the reality and organization of a culture. Similarly, reality itself can move in the direction of art.

Thus, according to the above argument, it would appear that there are two major possibilities for future artistic development. Art can join reality and cease to exist as art. If such be the case, a major change in the nature of economic, political, and social reality would have to occur. However, Marcuse advocates that instead of attempting to overcome the distance between art and social reality, truly avant-garde art should emphasize the gulf between what is and what should be. Such an art, an art of the unreal, must be estranged not only from the immediacy of real life but also from ". . . thought and behavior—even political thought and behavior."

In fact both possibilities for future art development coincide. The art of unreality becomes the art of reality when the larger social organization changes sufficiently. Art as a form of reality means ". . . the construction of an entirely different and opposed reality," and will lead to the goal of ". . . junction of technique and the arts, junction of town and country, industry and nature, after all have been freed from the horrors of commercial exploitation and beautification . . ."[14] It goes without saying that such a possibility for art depends upon ". . . the total transformation of the existing society: a new mode and new goals of production, a new type of human being as producer, the end of role-playing, of the established social division of labor, of work and pleasure."[15] All these are, of course, commonly shared goals, yet it remains for a political system to be devised out of current organizations that is capable of achieving them.

Questions that immediately spring to mind concern the sublimation or reinforcement of the motivations that serve aggressive and competitive instincts, organization and control of behavioral responses, and the notion of art as a factor equally compatible with both work and leisure. Such notions are not generally considered by art critics. However environmentalists, social scientists, economists, and experimental psychologists have addressed themselves to these questions.

[14] Herbert Marcuse, *On the Future of Art* (New York: Viking Press, 1970).
[15] *Ibid.*

Toward an Art of
Behavioral Control:
From Pigeons to People

> *We shall not only have no reason to admire people who endure suffering, face danger or struggle to be good, it is possible that we shall have little interest in pictures or books about them. The art and literature of a new culture will be about other things.*
>
> B. F. Skinner, *Beyond Freedom and Dignity*

WELL, IT ALREADY IS, you might say. One question is, will there be any art or literature at all in the new "controlled" culture the behaviorists advocate? The answer to the question might be, quite simply, no there won't because there will be no need. Neither art nor literature *as we know them today* will survive B. F. Skinner's controlled new world because we will have been deprived of the valleys that make them the mountains they appear to be to us.

Professor B. F. Skinner is among the world's most eminent psychologists in the field of behavioral studies since Pavlov. He is best known for his refinement of the concept of reinforcement; his book *Beyond Freedom and Dignity* (1972) has aroused considerable controversy that has spilled out well beyond the confines of his specialization—experimental psychology.

In brief, Skinner assumes that things today are not going well and that the development of a science of cultural control (behaviorism) is required if our culture is to survive. In so doing our culture

James Ver Hoeve: *Barriers Discarded.* 1969.

must take "survival" rather than "freedom" and "dignity" as its pre-
eminent value. Otherwise, he explains, "we shall be left, like Milton's
Satan, in hell . . . with no other consolation than the illusion that
'here at last we shall be free.' "

I am not going to summarize Professor Skinner's theories in
detail. Neither shall I pass judgment on the moral and ethical
implications thereof. Rather, I shall assume that the new science
championed by Skinner will, sooner or later, evolve despite for-
midable opposition from both right and left. Stephen Spender, the
poet, calls Skinner's ideas ". . . a kind of fascism without tears."
He claims the theories allow little room for the ". . . individuality
of the artist and the poet." Zbigniew Brzezinski, the Soviet affairs
specialist, doubts that Skinner's theories have much usefulness
". . . as a serious prescription for social-political organization."

Well, maybe yes, maybe no. At any rate the evolution of a science
for the control of behavior is as inevitable as was the development
of another similar science of control—the science of the behavior of
nature or, in other words, agriculture and its allied discipline, animal
husbandry. Skinner believes that humans, too, are in no way exempt
from cultural control.

However, unlike scientific control of plant and animal life, a major
obstacle to the development of a science of behavioral control of
human culture lies in two contemporary bugaboos: firstly, our ideas
about the autonomy of the individual (freedom), and secondly, our
insistence upon receiving credit for our behavior (dignity). Obvi-
ously, both these notions play significant motivational roles in con-
temporary art as in everything else. If we are to investigate the
implications of this new science for the art process, it follows that
we shall have to examine the relationship of freedom and dignity
to the art process. Thus the process is of greater interest than the
subject matter of art itself.

Therefore a close examination of Skinner's propositions may shed
some light on the present condition and future direction of art and
artmaking. In the notes that follow I should like to examine briefly
some of Skinner's views on the science of behavior and relate them
to broader developments in aesthetic and social areas. Hopefully,
by so doing, we may discover that:

1) several documents appearing in recent years reinforce Skinner's theories;

2) Skinner's suggestions are not nearly so threatening as they may appear;

3) they may provide art with clues to its present and future direction; and

4) we may discover that some contemporary artists are already working in a way that might be described as "prebehaviorist."

The fact that today's world is on a collision course with disaster is more or less accepted. At the same time everybody is looking for an economic, social, and political system that would allow people to live without quarreling and that might encourage a more equitable distribution of available wealth, a system in which there is minimal consumption of resources and minimal pollution.

Obviously some sort of systematized control—much more pervasive and persuasive than that extant today—is required in order to alleviate these enormous problems. This is where Skinner comes in with his suggestions for control not of behavior itself (something that he recognizes as old-fashioned and based largely upon negative reinforcement), but control of the cultural environment that determines behavior.

A major attempt to alert a large section of the intellectual and leisured population to the current unrestricted, lopsided, and dangerous growth pattern of the economy was presented in Washington in 1964 in a group of articles published under the title *The Triple Revolution*.[1] It was, according to the introduction by Roger Hagan, ". . . a rehash and a cry of amazement at the backwardness of our society in recognizing elemental facts of modern life and justice." The authors saw the problem facing mankind not as exclusively economic, or political, or legal but all of these together. And they noted: "Most of us believe that the current problems of our economy are early but integral manifestations of a malaise soon to be felt more desperately. . . ."

[1] *The Triple Revolution*: A Document issued in Washington, D.C., by an *ad hoc* committee on March 22, 1960. Introduction by Roger Hagan.

And, of course, that's exactly what has happened. However, *The Triple Revolution* was mainly a plea for specific economic, weaponry, and human rights programs. It was not a science, and it offered proposals that, more or less, supported a broader type of behavioral investigation and control. In so doing it confronted the problems themselves instead of the conditions or even the cultural *ambiance* that had produced the problems in the first place.

The similarity between Skinner's science and *The Triple Revolution* is that both offer a schema that claims to be essential if mankind is to survive. Both insist that "Our culture has produced the science and technology it needs to save itself. It has the wealth needed for effective action. It has, to a considerable extent, a concern for its own future." The main difference (in fact Skinner would not agree with it) lies in a major claim of *The Triple Revolution*—the thesis ". . . of the right of humans to wherewithal and dignified self-development according to needs and inclination rather than to production of economic value."

Here the two part company, decisively. Skinner insists that if our culture ". . . continues to take freedom or dignity, rather than its own survival as its principal value, then it is possible that some other culture will make a greater contribution to the future." And Skinner would confine the attentions of his science to those cultural factors that *determine* the "needs and inclinations" of humans, rather than those factors attempting to satisfy such needs.

Adding some urgency to Skinner's plea to abolish autonomous man—"Only by dispossessing him can we turn to the real causes of human behavior. Only then can we turn from the inferred to the observed, from the miraculous to the natural, from the inaccessible to the manipulable"[2]—is another study called *The Limits to Growth*.[3] This is a scientific, computerized analysis of world resources, population growth, and capital expansion that emphasizes

[2] The quotations in this chapter are from B. F. Skinner, *Beyond Freedom and Dignity* (New York: Alfred A. Knopf, 1972).

[3] *The Limits to Growth: A Report of the Club of Rome Project on the Predicament of Mankind*, ed. Donella H. Meadows *et al.* (Washington, D.C.: Potomac Associates, 1972).

the theory of exponential growth as opposed to linear growth. According to the authors:

> One of the most commonly accepted myths in our present society is the promise that a continuation of our present patterns of growth will lead to human equality. We have demonstrated in various parts of this book that the present patterns of population and capital growth are actually increasing the gap between the rich and the poor on a worldwide basis and that . . . continued attempt to grow according to the present pattern will [result in] disastrous collapse.

This thought, echoed repeatedly by Skinner, is in sharp contrast to traditional beliefs concerning growth and the benefits that will accrue from it. For example, in 1965 New York University economist Stephen Rousseau, reflecting the prevailing attitude, noted: "A higher long-term growth rate and our democratic values are complementary." Such a view is, apparently, no longer acceptable.

Therefore, the major difference between the stand assumed by Skinner and others is that, in order to prepare for a fair, livable world, such values as the long-term growth rate and traditional democratic ideals are neither viable nor desirable. In a similar vein Skinner points out that "We could solve our problems quickly enough if we could adjust the growth of the world's population as precisely as we adjust the course of a spaceship . . ." He admits that his proposals demand sweeping changes and that ". . . those who are committed to traditional theories and practices naturally resist them." (Skinner does not, however, refer specifically to democracy, or any other political system.)

Skinner insists that by ". . . questioning the control exercised by autonomous man and demonstrating the control exercised by the environment . . ." we will be on the path toward avoiding disaster. He writes: "The intentional design of a culture and the control of human behavior it implies are essential if the human species is to continue to develop." Thus, it would appear that the dangers to our culture that have been demonstrated by *The Limits to Growth* are precisely the dangers that Skinner has foreseen and feels can be effectively checked only by the further development

of a science of behavior, which demands a big change in traditional ways of thinking.

What then is the artist, a traditional champion of the autonomy of the individual, going to do? How will he fit in? Is his role threatened? Indeed, is the artist, as he stands today, a reactionary?

These are major questions. At this point they are unanswerable.

However, what should be pointed out at this stage is that all this is not quite so alarming as it may seem. What may, indeed, be frightening is the enormous opposition that will appear: the reluctance of the specialist as well as the individualist to go along with Skinner's propositions.

Skinner anticipates a sort of "rearguard action," which will insist upon the theory of the autonomy of the individual, coming from specialists in virtually every field, from political science and religion to economics, city planning, and family life. "These fields have their specialists and every specialist has a theory and in almost every theory the autonomy of the individual is unquestioned."

However, Skinner claims that it is useless if not reactionary to resist the inevitable—the decline of the autonomy of the individual. It is equally unwise to refuse to exercise available control. The science he advocates will, of course, investigate just what control is available and how it can be applied. Such things have not been thought about yet. In effect, the science of behavior will concern itself with the design of the culture. Skinner does not see any reason to fear or suspect the designer of the culture as though he were some sort of outsider merely engaging in expensive experiments. Instead he insists "The designer is not an interloper or meddler. He does not step in to disturb a natural process, he is part of a natural process."

Of course the very idea of a "culture designer" smacks of fascism. However, to the criticism that he is sympathetic to fascism, Skinner retorts that this depends on whether democratic cultures are able to "take advantage of what we are learning about human behavior." What it seems to boil down to is that neither democracy (capitalism) nor communism—both of which depend on exponential growth and attempt to control behavior rather than the causes of behavior—

can possibly tolerate Skinner's "behaviorial science." And, if his science is as essential to survival as he claims, then it is fairly obvious that neither democracy (capitalism) nor communism has much of a future.

Those presently engaged in the design and redesign of cultural practices are not, according to Skinner, artists. They invent ". . . better mousetraps and computers." The new cultural designer will, in fact, be engaged in the design of contingencies. For example, ". . . contingencies under which students acquire behavior useful to them and their culture. . . ." In general Skinner suggests we ,must look to those contingencies ". . . that induce people to act to increase the chances that their culture will survive." Such inducements will not be forthcoming in literature and art, which ". . . permit one to 'sublimate' other kinds of troublesome behavior." Art is thus viewed as something possessing protective or tranquilizing qualities—it is, at best, a holding action to be eliminated.

Skinner criticizes yet another condition closely associated with artmaking and art appreciation—leisure. We are led to believe that leisure, in large doses, is absolutely essential to the manufacture of art. Leisure is a prerequisite for the enjoyment of art and for any kind of artistic participation. If leisure is viewed as a questionable, even undesirable, condition, then the artmaking system is deprived of its major form of sustenance.

The signers of *The Triple Revolution* predicted, back in 1964, a system of ". . . almost unlimited productive capacity which requires progressively less human labor." They thought, at that time, that ". . . society no longer needs to impose repetitive and meaningless toil upon the individual . . ." Furthermore they thought (rather naïvely, it now appears) that a major social problem was to ". . . develop ways to smooth the transition from a scarcity, full-employment society to one in which the norm will be either non-employment . . . or employment on the great variety of socially valuable but nonproductive tasks made possible by an economy of abundance." The implication was that people would have a lot more leisure time and, therefore, there would be a corresponding renewal of interest in the arts. Of course, *The Triple Revolution* people seem to have been wrong on both counts. Skinner, on the

other hand, is not sure that ". . . affluent culture can afford leisure." Yet there has been, in some societies, an increase in the leisure time available to most people. Leisure is no longer a condition enjoyed only by a few. However, Skinner points out that ". . . leisure itself does not necessarily lead to art . . ." and he goes on to note, in apparent agreement with *The Triple Revolution* people, that "Leisure is a condition for which the human species is badly prepared, because until very recently it was enjoyed only by a few . . . there has been no chance for effective selection of either genetic endowment or a relevant culture."

If one agrees that leisure and art are necessarily related, then we come to another challenge to art laid down by Skinner. He claims "Leisure is one of the great challenges to those who are concerned with the survival of a culture because any attempt to control what a person does when he does not need to do anything is particularly likely to be attacked as unwarranted meddling." He goes on to note, in a particularly threatening vein, that

> Life, liberty, and the pursuit of happiness are basic rights. But they are the rights of the individual and were listed as such at a time when the literatures of freedom and dignity were concerned with the aggrandizement of the individual. They have only a minor bearing on the survival of a culture.

Thus, without stretching things too much, it would appear that what Skinner is saying is that art (a product of and for leisure) itself has only a minor bearing on the survival of the culture.

In the final analysis one must examine and reexamine the process and motivation of artmaking rather than the subject of art, if one is to determine whether or not notions of freedom and dignity are being effectively uprooted. Clearly, autonomous man is not about to fade quietly away. Yet, according to Skinner, he must. "His abolition has long been overdue. Autonomous man is a device used to explain what we cannot explain in any other way."

Artists traditionally insist upon freedom and dignity of man, though frequently what they really are insisting on is their own freedom and dignity and the freedom and dignity of fellow artists. They have been expected to champion the cause of humanity and

to secure man's dignity (i.e. to give and take credit) where it has
been neglected. Hence we have the films of Andy Warhol, the pop
art of James Rosenquist, theatrical productions from The Playhouse
of the Ridiculous, and on and on. However, lately, artists seem at
the same time to have been turning away from the subject and
concerns of autonomous man. Trends within the so-called concep-
tual movement seem to have helped artists come to realizations that
are, in fact, critical of humanity and of the sacred "integrity" of the
individual. Thus they demonstrate Skinner's contention that autono-
mous man ". . . has been constructed from our ignorance and as
our understanding increases the very stuff of which he is composed
vanishes."

For example, artists concentrating on trivia, ignoring time-tested
clichés that insist that man is a free object possessing the power to
determine his own actions and to receive credit in return, seem to
contribute to our understanding of the artificially motivated be-
havior of man. They are heading toward an attitude in which there
is no such thing as "autonomous" man, ". . . the inner man, the
homunculus, the possessing demon, the man defended by the litera-
tures of freedom and dignity." They accomplish this precisely by
their preoccupation with the banal and the ridiculous and by their
appreciation for the obsolete.

The literature of art and aesthetics contains many references to
the artist as being, somehow or other, important because he helps
determine or design cultural practices. Indeed, references to the
artist determining the visual language and affecting the behavior,
life-style, and sensibility of people abound in the history of art
theory and art criticism.

For example, William Morris, the Pre-Raphaelite critic and de-
signer, was deeply concerned with the ". . . vital connection be-
tween [artists'] work and the happiness of the people . . ." (Selec-
tions from the Prose Works of William Morris, A. N. R. Ball ed.
[Cambridge, 1931]). And Morris himself wrote: "I hope we know
assuredly that the arts . . . are necessary to the life of man if the
progress of civilization is not to be as causeless as the turning of
a wheel that makes nothing."

More recently Herbert Marcuse wrote that art could become

". . . a productive force in the material as well as cultural transformation . . . as such a force would be an integral factor in shaping the quality and the 'appearance' of things, in shaping the reality, the way of life" (*An Essay on Liberation* [Boston: Beacon Press, 1969]). In a similar vein Morse Peckham defines a work of art as ". . . any perceptual field which an individual uses as an occasion for performing the role of art perceiver" (*Man's Rage for Chaos* [New York: Schocken, 1965]).

What is new is the fact that this almost standard art-cultural function is being deliberately appropriated by Skinner's new behavioral science.

Nobody would say that Skinner's "cultural designers" are the same as today's artists. Unfortunately most artists today are still engaged in aesthetic exercises that bear little relation to cultural reality. They are, to be sure, primarily concerned with the production of abstractions, sort of visual poems; they are engaged in manipulation of the mechanics of the visual language, no matter how remote from social behavior.

As a result the new attitudes evolving from Skinner's proposals place a strain on an already critical identity problem that artworkers have to worry about. Skinner is perfectly aware of this problem and seems to have, at least in some ways, anticipated it. He said in *The New York Times*: "I accept the possibility that in a more peaceful world, in a world in which there were no troubles, there would be very little we'd recognize as the art of the past." And, he adds that he would certainly prefer to live in that world.

I said that he *partially* anticipates the problem because he does not really seem to appreciate the seriousness of the implications, for art and the artist, of his theories.

For example, just one problem is that of artistic judgment. If, as Skinner claims (as do others), "Goodness, like other aspects of dignity and worth, waxes as visible control wanes . . . Hence goodness and freedom tend to be associated," then the issue is that there may, in fact, be no artistic criteria at all. Therefore one artwork is as "good" as another and one artist as "good" as another. Since today the major motivation in artmaking is qualitative, in one way or another, the *raison d'être* of art itself becomes suspect. After all, all art seems to aspire to some higher goal of perfection

or even "spirituality." Nevertheless, it may seem corny to refer to the cliché "beauty is in the eye of the beholder." Yet Skinner warns: "Some part of what we call red, or smooth, or sweet must . . . be in the eyes or fingertips or tongue of the beholder . . ." It follows that the mechanics of art criticism may have to abandon its claim that art itself aspires to pleasure or something like it. Skinner notes that "Epicurus was not quite right; pleasure is not the ultimate good, pain the ultimate evil; the only good things are positive reinforcers and the only bad things are negative reinforcers."

To make matters worse, let us consider what happens when dignity is threatened. The "credit" an artist receives for his work is, of course, an important, if not the most important, motivation. Frequently the "credit" is about all there is that the serious or even successful artist can count on. But Skinner warns that ". . . as an analysis of behavior adds further evidence, the achievements for which a person himself is to be given credit seem to approach zero, and both the evidence [the artwork in this case] and the science which produces it [art] are then challenged."

If Professor Skinner's science is to evolve and become a major force determining social reality, then the artist will probably move away from the traditional aesthetics and, instead, create works or "situations" that cause man to observe, analyze, or criticize his behavior in one way or another. Though this may seem a far-fetched possibility and may even appear to be a total denial of the artist's role, or even worth, this need not be the case.

There are already indications that the artist and art itself are moving in such a direction. Obviously, such developments as conceptual art, which minimize the importance of the aesthetic object, spring to mind. However, we have already encountered artworks that are constructed primarily with the resultant behavior of the observer in mind. Examples of this new phenomenon include, of course, the Happening, political "guerrilla" street theatre, in particular, *The Guerrilla Art Action* group of New York.[4]

However, what I am leading up to here is something that is even

[4] Under the auspices of Jon Hendricks and Jean Toche.

more totally committed to audience behavior (and not simply participation) or works designed to increase political awareness. I am referring to works that have as a primary purpose the observation, examination, and criticism of audience behavior. Therein lies the authentically new "prebehavioral art" that is truly in keeping with the meaning and the implications of the science of behaviorism.

One example of this type of art—an artwork that is interesting only when the response of the observers (participants) is examined—was offered by a young artist in 1972 at the O. K. Harris Gallery in New York. The artist, Mike Malloy, set up an apparatus that in some ways probably resembles Professor Skinner's "pigeon" contraptions. (Therefore it will be read as a clumsy, though highly innovative, prebehaviorist artwork.) Visitors to the gallery were required to put a dime in a turnstile, wait in line, enter a curtained booth, and, once there, could, if they so chose, push a button that resulted in the chemical killing of a laboratory ant in a transparent plastic shell. One could choose not to kill the ant. "You can tell who the murderers are before they go into the booth" remarked an attendant. And what is obviously most important is whether or not the observer kills the ant. The work itself is important only in relation to whether or not it functions as a laboratory device, in much the same way as Pavlov's kennels or Skinner's coops helped create the enclosure for the most ideal observation and control of the animal's behavior.

It should be added that an audience watching people go through Malloy's contraption at O. K. Harris knows, from a sound heard outside, whether or not the person in the booth has killed the ant.

Other than the fact that the artwork described above was presented at one of the most prestigious and trend-setting galleries in New York, there are several indications that a behaviorist-oriented art movement has begun. A "theme" of the 36th *Venice Biennale* (Venice, 1972) was stated as "Opera o Comportamento" (Work or Behavior), and artists advocating behaviorism over aesthetics challenged their more conservative colleagues at "*Documenta 5*" (Kassel, 1972).

The most immediate conclusions to be drawn from the new attitude probably lie within the area of art education, which finds itself in a precarious position. Obviously the education of the artist will

have to change in a very complete manner. If the artist is to be
effective and useful, instead of learning the fundamentals of color,
draftsmanship, design, and composition (prevailing goals that,
clearly, have failed miserably anyway), he will have to be familiar
with sociology, urban planning, industrial design, and experimental
psychology. Indeed it is perfectly reasonable to expect that the
traditional emphasis in art education will shift dramatically and
that it will not be long before we realize that the so-called sophis-
ticated art courses offered at "advanced" schools and institutes
are about as obsolete as the teaching of watercolor and embroidery.

It has been demonstrated among the most advanced artists of our
time that their achievements in art have come about almost as a
reaction against their training. The willingness to change and in-
novate that is standard procedure at all art schools is merely a
gesture. Authentic innovation is usually either frivolous or artificial.
Probably the most hopeful and positive indications of change lie in
the area of interdisciplinary studies, which are slowly and reluc-
tantly being accepted.

James Rosenquist

His junior high school art teacher suggested he "make it abstract."

"No, I don't paint anything abstract. I only paint what I see," young Rosenquist firmly answered.

THE READER IN SEARCH of material on the artwork of James Rosenquist has not far to look. There are at least two major works in print and they are both outstanding pieces of criticism as well as important extrapolations. Best known is the Gene Swenson article[1] in which Swenson, the interviewer, remains behind the scenes. In fact, he allows himself not a single word and Rosenquist, edited, holds forth on his background as a sign painter ("I painted things from photos . . . after I did it, it felt cold to me . . . I like to paint them as stark as I can."), his thoughts on billboards as "apart from nature," and his special views on color.

Rosenquist told Swenson about how he "started painting Man-Tan orange. . . . I always remember Franco-American-Spaghetti

Quotations not attributed in the text are from a recorded discussion between the artist and the author in New York City on April 15, 1972. They have, of course, been edited for publication.

[1] Gene Swenson, "The F-111: An Interview with James Rosenquist," *Partisan Review*, 32 (Fall 1965).

orange." More recently the artist observed: "When I was painting
signs . . . they'd say the beer didn't have enough hops in it. It was
the wrong color. That meant I'd have acres and acres of rendering
to do over again."

A recent critique published on Rosenquist is Marcia Tucker's
detailed monograph published by the Whitney Museum as the
catalogue for the 1972 show.[2] n her essay, Tucker outlines the
major periods in the artist's life and relates them to specific paint-
ings: "The experience of painting huge images at close range pro-
vided the initial impetus toward dealing with issues of size, scale,
distance, selectivity, abstraction . . ."

There is, however, one comment by Tucker that I should like to
question: "Many of Rosenquist's images come directly from his
years as a billboard painter, *but they are not used as ironic com-
mentaries on the nature of a society that produces billboards . . .*"
(Italics mine.)

Actually, it is obvious that Rosenquist possesses a strong identifi-
cation with American social, cultural, and behavioral patterns.
Therefore it would seem that the stark yet blank images are, at least
in the end, highly ironic commentaries on the nature of a society
that produces everything from canned spaghetti to terrifying fighter
bombers; our emphasis on surface qualities and vanity leads us to
"ranch"-type houses that are ecologically destructive, both in con-
cept and fact, a preoccupation with destructive, oversized, un-
maneuverable cars, chrome, glitter, tin foil, and artifically colored
packages for tasteless, chemically-fortified imitation foods. "Well,
who wants to eat all the time. I eat anything. Food color I remem-
ber," he says.

And perhaps above all, his paintings are about a society that
hates nature and feels threatened by the landscape—a society that
is insanely driven to stamp out life and substitute the vacant, the
artificial. And that, it seems to me, is what Rosenquist's paintings
are all about and why they will remain irritating yet enormously
attractive documents for a people in crisis, merrily sliding downhill
at breakneck speed.

[2] Marcia Tucker, catalogue of the "James Rosenquist Retrospective" exhi-
bition, Whitney Museum of American Art, April 12–May 29, 1972.

Rosenquist: We are living in very bad, hard times.
Battcock: You mean lack of civilization?
Rosenquist: Yeah. And insanity.

In the random notes that follow I will not deal with several con-
cepts that are important in Rosenquist's work, such as "middle
ground imagery," "peripheral vision," and his preference for a near-
past that is not yet nostalgia. Such issues are thoroughly covered
by other writers, including Swenson and Tucker.

The precise reasons for his choice of subjects and images and
juxtapositions are difficult to determine. Rosenquist himself is not
prone to give out simple answers. When, in 1956, he first saw *White
Flag* by Jasper Johns, he thought it was political: ". . . from his
painting of a target I got a very strong feeling. It seemed not to
give out any answers . . . and the more you looked at it the harder,
the deeper it got."

And, speaking of his own work, he says: "There are things put
together that are mysteries. I like to collect those mysteries."

"I notice you said 'collect' rather than solve," I said.

"I can't solve them," he replied.

Therefore it may be interesting to relate at least one specific work
to a specific event, a source. In general his subjects do not refer
specifically to, say, the war in Vietnam. Yet they invariably are
about hypocrisy and involve unnatural, clumsy juxtaposition and
negative, hostile phenomena.

One work, *Capillary Action II* (1963), a sculpture, involves a
tree. The tree is sort of split, and electrified. A cable dangles. The
tree is connected to a structure it supports.

The origins of this work can be traced to a visit Rosenquist made
to an amusement park in Texas some years ago.

In Tucker's catalogue essay there appears a quotation attributed
to Rosenquist about an amusement park in Texas. Immediately fol-
lowing the quotation, Tucker observes: "When Rosenquist talks
about his ideas and his work, he is rarely factual or objective . . ."

"That's baloney," claims Rosenquist. And he says of Tucker's
quote: "I don't think I said that. It sounds like a tape, but I don't
think I said it. She made it sound like a quote from a tape but it's
not."

James Rosenquist: *Capillary Action II*. 1963. Mixed media. 102" x 66" x 55". Collection of National Gallery of Canada. Photograph courtesy Leo Castelli Gallery, New York

However, the point is that *Capillary Action II* originated from an observation Rosenquist experienced at that Texas amusement park. He says:

> I'm interested in facts and events. I was in Texas. I went to an amusement park and saw a lot of things—I have a number of experiences where the dry Texas landscape was—with an amusement park—unnatural.

He then went on to relate an incident that, ultimately, led to the work:

> At the amusement park I went to a taco stand. It was about ninety degrees, and I felt a draft on my feet. The air was completely still, yet I felt a draft. I looked up into a tree and there were three barbershop fans bolted to the tree, creating an artificial draft, outside. . . . The artificial breeze, the peculiar place—a tree that had not been turned into lumber yet, yet it was bolted onto something. I had this feeling I was being bolted up. . . .

The result of this event was *Capillary Action II.*

Other observations from that same amusement park visit included one about a parrot. At one "attraction" there was a parrot cage with a live parrot:

> Inside the parrot cage, with the parrot, was a little speaker. There was, obviously, a guy hiding someplace. When somebody would come near the parrot cage, the voice would say "Hi little girl! I'm Polly the parrot. What's your name, little girl?" During all this the live parrot in the cage was sleeping. Every time the voice came on the parrot would shudder a bit, slightly annoyed.

Thus Rosenquist's fascination, revealed in his works, for unlikely juxtaposition and the combination of the outrageous with the slightly ridiculous imagery is grounded in everyday experience.

He recalls another event from the amusement park:

> I went to the Louisiana River Boat. College students dressed in striped shirts and straw hats carried a pole to push the boat along. I sat in the last seat, and when the boat started moving I noticed,

out of the water came a piece of gear and it pushed the boat along, on a track. The stream was curved but the thing went in angles and jerked. It was a winding, S-shaped ditch, but the boat went in a geometric pattern.

Thus we have yet another example of what could, perhaps, be interpreted as a sociological evaluation of a pompous and hypocritical situation in which distortion and illusion were the thing. Of course, in real life, we don't have handy amusement parks to remind us of empty appearances and distorted ritual. As adults we flock to the College Art Association Meeting at the San Francisco Hilton, where they have framed Mona Lisas in each of a thousand bedrooms, miniature Poussin allegories labeled as "Rembrandt," and elaborate chandeliers that produce no light.

My purpose in detailing the amusement park episode is that it seems a particularly specific demonstration of how the artist chooses his subjects—how they come to his attention and how they are finally realized in a painting. Rosenquist avoids simple explanations. For example, when I proposed that, in effect, he exaggerated an event and interpreted it in a nonliterary way (a stupid and erroneous suggestion), he patiently replied: "Yes. No. It was a quality of feeling." However, exactly what kind of feeling is not easily determined. Rosenquist recalled another incident in Texas, at the scene of a Dallas Cowboys game: ". . . people were so uptight they were throwing whiskey bottles into the street. I remember broken whiskey bottles crashing on the hot pavement—it was rough and tough there."

Rosenquist's greatest painting is probably the *F-111* (1965).

Battcock: Your painting *F-111* is, for America in the late sixties, perhaps the equivalent of what Picasso's *Guernica* may have been in the thirties.

Rosenquist: I doubt it.

Battcock: Why? Because you think *Guernica* was not powerful, or because you doubt the power of your own picture?

Rosenquist: Both.

Battcock: Oh, I see. You don't think *Guernica* was ever a powerful picture.

James Rosenquist: *F-111*. 1965. Oil on canvas with aluminum. 10' x 86'.
Photograph courtesy Leo Castelli Gallery, New York.

Rosenquist: I like it a lot. I still like it. But powerful what? How can it be powerful? I was in Florida recently and met a lot of angry socialists in the Socialist Club. Very tough. So tough I thought they might be CIA agents. They said "Yeah, man. But don't you think the Cuban revolutionary posters are art?" Yes, they might be art in the guise of a Cuban revolutionary poster. My feelings are idealistic. They are not tools for politics. My feelings just came out in that *F-111* painting. I have feelings now, and if I started working now, the idea that I have may be political or it may be artistic. I don't know.

Battcock: About *F-111*. Do you agree with interpretations that this is a social and political commentary?

Rosenquist: Yes it is. A social and political commentary. But I can qualify that by saying that . . . I don't cast out any feelings I have when I'm working.

Later Rosenquist will say, and without contradiction: "My feelings just came out in that *F-111* painting." I told him that walking into the Whitney installation of the painting, one almost shudders, that the painting retains an aggressive, alarming presence somehow. He replied:

> Really? I don't know. When I showed it, I didn't read any criticism about it. I have a feeling for another painting now. I have a very angry feeling and it has nothing to do with art at all. It has to do with President Nixon and the latest war escalation. I just see— I don't know—I see a lot of suffering. A lot of suffering. When one sees loads and loads of kinds of suffering, it gets to be a weight. When you see a government perpetrating a lot of that feeling—that and the memories of those feelings gets to be incredibly overbearing. You begin to feel like a Nazi.

Later, he admitted, he did get around to reading the criticisms of *F-111*. He said: ". . . if it's not misconstrued, it's like someone helping you say something that you want to say. The things I do—one can hope they escalate to have a fatter meaning. You don't think of all that . . ."

The painting *F-111*, the reader will recall, contains images of parts of the jet fighter airplane, spaghetti, a healthy little girl under

a hair drier, and so on. It covers all four walls of a room and it is painted in sections. The colors are bright, raw, yet somehow bland and ordinary. It is a vulgar paean to consumerism, vanity, militarism, and insensitivity. Here, as a final comment, are Rosenquist's thoughts on the painting:

> I thought it was very silly . . . my life in general. I was questioning my reality and my feelings and my money and other people's money being paid for income taxes that became war weapons— originally income taxes were supposed to be donated to the community and become some kind of social arrangement. . . .
>
> So it seemed that if I made this thing and I put it up for sale, it would be strange selling pieces of it—I thought it would be a horrible joke. That people would be buying the same thing—a representation of what they buy constantly, like war weapons. In California people have three cars and three and a half children because they work in airplane factories that produce them. The same on Long Island. Mainly I was interested in doing something where I control peripheral vision.

The Wings of Man

THE UNIQUE CHARACTER of America today is most strongly represented by the Midwest—its landscape, its architecture, its highway-(as opposed to pedestrian-) oriented culture, and transportation patterns.

On the other hand the culture of the California surfers is a carbon copy of the phenomenon at Biarritz, Rio, and Casablanca. The urbane and urban patterns of culture, transportation, and communication of the Northwest are predominantly European. The conservative, genteel patterns of New England also originated abroad.

The unique, contemporary American living and thinking patterns originated primarily in the Midwest. Our modern attitudes in art toward art, toward visual and physical communication and transportation—the distribution of ideas, things, and people—can be traced to one particularly important Midwestern event: the Homestead Act of 1862.

We find that in painting (as in the real estate of the Homestead Act) we are dealing with a flat surface. And real estate shares with *sculpture* one major similarity. Both phenomena involve the ground as a base. That same condition is what separates painting, for example, which is *on the wall,* from sculpture, which is on the floor, or ground. It *also* serves to differentiate real estate (which is, in this sense, *the* ground) from *transferable* objects (such as typewriters or bottles of wine) that do not demand space on that most precious of spaces—the ground.

Now I have said that both painting and sculpture are essentially the same as real estate because of their reliance upon a flat surface, or the ground. There is another similarity. All of them depend upon boundaries. The edges of a painting are its boundaries; the fences or surveyors' statistics delineate the boundaries of a piece of real estate. A boundary, as we know it then, carries a message of ownership, of control, of authority. In the modern world boundaries are anachronistic. To us a boundary is, at best, an abstraction. In the largest sense, for example, boundaries between countries are places where the police stop you and search you—procedures that, someday, will be declared a violation of human rights.

So, although painting and real estate share common characteristics, it is not necessarily to the advantage of either.

The Homestead Act gave government land to settlers and an illusion to a nation. There was *land* for everyone, everyone was entitled to land. Even though the utopian promise of industrialization had been broken, there awaited a garden on earth for man.

Thus the landscape was converted into a development. It was parceled out to private owners. "Public" lands were available to be turned over to the people—in terms of private ownership. Freedom was equated with ownership of land, rather than with the existence and availability of public lands. The landscape was fragmented on a drawing board with surveyors' tools rather than naturally—by terrain. The stage was set for a new attitude toward land, toward living patterns, and toward communications and transportation systems. In this new world the urban tradition began to disintegrate. The culture of urban man began to crumble, although nobody told Middle America.

The changes led, ultimately, to a new architectural scheme of pedestrianless downtowns. The new architecture is automobile-perspective architecture rather than pedestrian-perspective architecture.

I would like to show that the social and economic heritage of a culture can be a factor in the determination of its art. It would also be nice to indicate that, indeed, what's important about art might not be connected *directly* to art itself but may lie within the periphery of visual experience. In other words, the study of the subtleties of color, for example, may actually *aggravate* an already un-

acceptable art scheme, because such endeavors obscure the real potential of art—how it functions as a vehicle for improving the awareness of man and improves man's ability to appreciate with enthusiasm his own life-style. What the preceding sentence means is simply this: art can still be of value as long as we are able, in the words of Regis Debray, to ". . . free the present from the past" and begin to think about the sensitivity and imagination of living man.

The "homestead vision," which is part of the general American dream most artists unconsciously reflect, is an attitude that has proved wrong. It has to be banished not only as a reality but also as a dream leading to wars, deceptive ecological attitudes, self-pride, and antiquated economic notions. Already some people are taking the opposite, though not the only viable, attitude by promoting the dream of communal living and ownership of land and property. Most of today's artists, instead of proposing new and better dreams that are more appropriate to this time, are merely reflecting dangerously old dreams. As a possible alternative to Marcel Duchamp's "I found it, it's mine," there is the possibility of "Everybody can do it, it's yours."

The *vision* of an estate for everyman—even though it would never be realized—can be related to contemporary concepts within the visual communication area. First, however, it's necessary to stretch our definition of *visual* a bit. If we are prepared to recognize, say, the typical suburban shopping center as a communicative document within the visual disciplines, then there is no problem. (In other words, can we accept the shopping center as a visual phenomenon no less important than a painting?) However, if we still insist that art, in order to be functional must incorporate remnants of easel mechanics, for example, then this article will make no sense whatsoever. (By *easel mechanics* I mean paint, applied according to the principles of composition and connoisseurship, upon a flat, limited surface.) Of course, it is the easel mechanics that is, nowadays, quite remote from daily communications experience, and our shopping center that is of the moment. Perhaps such a condition militates against effective understanding in authentic visual communication. Marshall McLuhan reminds that we cannot understand the new until it becomes old. Then, it's usually too late.

The new condition is reflected, as mentioned above, in the automobile-perspective architecture encountered by someone in a car. Good examples would be drive-in restaurants; gasoline stations complete with their fake colonial facades and gables; offices and apartment buildings that are entered via automobile; motels with their tiny room-houses that one enters from the outside rather than from a common corridor; and, in general, structures that one drives by rather than walks by.

One city that possesses a unique architectural scheme, essentially in automobile-perspective, is Washington, D.C. The city is constructed almost entirely from an automobile point of view, which is typified by pompous undersized buildings (compared to New York's pedestrian-oriented skyscrapers) that are separated from deserted sidewalks by tiny, artificially landscaped ribbons of green with a few shrubs to provide reassurance to motorists and to protect them from direct confrontation with the incompatibility of the pseudourban design scheme. The motorist is at home in the rural landscape. The city is not a "natural" landscape for the automobile. The bits of green and tiny plazas (typical of Washington) are an attempt to disguise the inconsistency.

New pedestrian-perspective architecture is shown in, for example, the Guggenheim and Whitney museums—mostly by way of architectural tampering with traditional horizontal-vertical (sidewalk/building), right-angle relationships. The International Maritime Union's former administration and welfare buildings in Manhattan both illustrate the same principle.

The point is, simply, that the pedestrian is a vertical object that moves upon a horizontal plane. The motorist is more or less prone and is also insulated by the protective enclosure of the vehicle. The shape, size, and place of the perceiver always determine, to some extent, the perception of the object—its shape, size, color, placement, etc.

Today's most common perceptions in all-America can be traced to the vision represented by the Homestead Act of 1862, in which the end of rail transportation could be predicted (even though the railroads, particularly the Illinois Central that profited most from the Homestead and other land-grant acts, were important sup-

porters) as well as the gradual disintegration of traditional European and Eastern urban social and cultural patterns.

Trains are to ships as feet are to cars.

The railroads advertised free or cheap land and encouraged settlers to take advantage of the opportunity for homesites out in the middle of noplace. Thus the corporations planned to populate markets for their products, which were transportation and distribution systems. However, it was a mistake and a self-defeating plot.

The trains (not being extensions of the feet, as is the car, because the train cannot go everywhere) had to stop at the end of the rails, and passengers had to seek other transportation that would take them *exactly where they were going*. So people bought covered-wagon-type vehicles that were also temporary homes, and when they arrived at their land, they frequently had to live in the wagons until more permanent housing could be obtained. Thus wagons became extensions both of one's feet and one's home because they could go places the railroad couldn't go. They were also usable to cover distances that could, alternatively, be covered by foot—unlike the train that was not employed as an alternative to foot travel. (Subways, of course, do compete with foot travel in the cities, and that makes them buses rather than trains.)

Thus the railroad, as passenger transportation, came to be thought of as something you take only *once*—thereafter it was not practical transportation for getting to the isolated, lonely homestead. Obviously railroads could never directly serve people in isolated locations. In order to visit neighbor or market, one couldn't take a train.

The railroad was replaced first by the car and, afterward, by the airplane—mostly by the airplane and not because the plane is faster, cheaper, more comfortable or more convenient than the train (frequently, it is none of these), but because it could be related to the person, to the self in a sensible way. Eastern Airlines informs us they are "The Wings of Man." Man's communication patterns, from the ancient Greek Kouros to Rock, are always extensions of the self.

So our "homestead vision"—a vision of land for everyone, a vision of a little self-sufficient world far away from industrial chaos—remains a vision. However, like all visions, it was something "good." Thus it is difficult to blame this good vision for today's social and

ecological ills, yet it is mainly that vision and its perpetuation that is the single most destructive factor in modern America's social decay. Indeed, we are frequently told today that we must repair social damage *in order to preserve* this debilitating illusion.

Litter, discarded beer cans, junked cars, and vandalism are not causes of ecological ravishment. Rather they are the result of a destructive attitude that values open space in a paradoxical way. Open spaces that are squandered by being parceled out or rendered useless by ruthless economic exploitation cease to exist. At the same time, we thoughtlessly blame "crowded conditions" in cities for urban ills. In fact, the open spaces should have been preserved and the cities should have become much more crowded. Only then would our urban centers have maintained their health. Density is the essential component of urban environments and only density will provide for feasible maintenance of distribution systems that are based upon the economics of concentration. Under such circumstances the necessity for throw-away containers, pre-packaged foods, cars, superhighways, and all symptoms of severe intercultural friction would become relatively minor threats.

A society that requires each family to possess two cars is apt to encourage three airlines to compete expensively and wastefully on the Houston-Chicago run. Each will take full page "ads" in as many newspapers as they can think of, and squander millions of dollars and hours on extravagant and stupid effort. Planning and regulation, as has been pointed out so often, rarely seems to enhance the style of life. Have we become convinced that waste, enslavement, and duplication can result in economic abundance and efficiency? Why else do we encourage several television stations to compete ruthlessly with one another over absolutely nothing at all? The eyesore in the New American Community is not the slums, or abandoned railroad depots, but rather the numerous churches (and supermarkets) each of which boasts its own black-topped parking lot, to be used only on Sunday mornings and Tuesday evenings and to be filled only twice a year.

If private ownership of a house and a plot of ground, complete with a two-car garage and driveway, becomes a value that one is supposed to defend with one's life, then significant cultural growth,

which necessarily depends upon intelligent distribution and effective, sympathetic utilization of communal spaces, will never be realized.

How do these tragically misdirected efforts pertain to art? The object of cultural communication, be it cinema with its mechanical procedures, painting with its surfaces and colors and walls, sculpture with its claim for space on the floor, or dance with its demonstration of intercultural exploration, depends primarily on prevailing conditions for information distribution and reception. Alas, these are determined according to the ways in which a man lives, moves, spends his time, eats, learns, and seeks solitude.

In other words, by art we mean the way we live now, and that "way" is determined by visions, illusions, aspirations, and patterns that are totally beyond the grasp of everyman. And that explains why art itself is also totally beyond the reach of the people.

Our communication/distribution/information systems are essentially private and therein lies the problem. They are private devices that lack authentically humanizing control. Television is a communicative idiom for private homes, for private viewing, in private circumstances. So are paperback books, phonograph records, radio, and frozen TV dinners.

Beer that comes in disposable cans and bottles is intended primarily for private consumption. In public situations we are more likely to drink beer out of glasses that are reused. A television program is designed for viewing in intimate or private circumstances. The TV commercials, by far the most brilliant documents transported by the medium (in television the regular programs are the price the viewer pays for the commercial), are designed primarily for private reception. (Demonstration: Screen television commercials on 16mm apparatus to a large group of people. Those very same, visual packages that are soberly absorbed in the living room suddenly become hilariously funny, and contain, perhaps, some embarrassment caused by the obscene content that becomes apparent in a public situation.) It's only by accident that television programs don't appear to be quite the "eyesores" that discarded beer cans are, because they are both the same thing.

The nineteenth-century homesteaders, because of their isolation,

1971 Oldsmobile Luxury Sedan. Photograph courtesy General Motors Corporation.

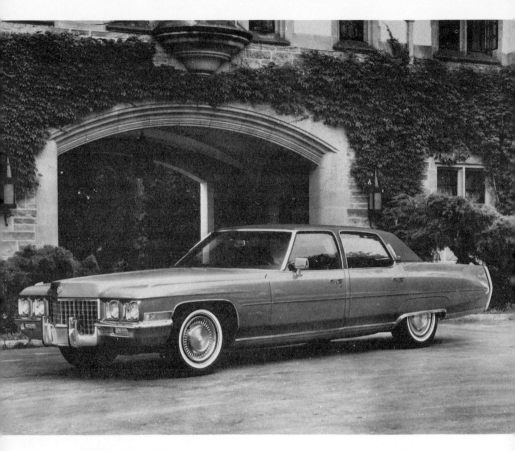

1971 Cadillac Fleetwood Sixty Special Brougham. Photograph courtesy General Motors Corporation.

had special need for protection. This need led to a protective attitude toward property and home that was motivated primarily by fear of attack by savages—as opposed to our more modern protective fears. The wagon offered more than transportation and a home. It provided a measure of protection from Indian attacks. Today's big, American automobile differs from the European car in that it is so much larger. It protects the riders from attacks by the landscape (rather than by savages). The motorist escapes confrontation with temperature, smells, texture of the roadway, noises, and threats from the highway and from other vehicles.

(The car as a house has been widely used in movies: particularly important psychological scenes happen inside a car or bus— note the films of Alfred Hitchcock and Jean-Luc Godard. Drive-in movies are primarily a version of television rather than cinema. One brings the *home* to the movies. It is not necessary to be quiet or look nice, you can drink beer or take off your clothes, you can regulate the sound. In art, Conceptual artists, such as Douglas Huebler, have used the car as a studio. Huebler made a conceptual piece that involved taking a photograph every ten miles alongside the road.)

Thus the design and form of the homesteaders' wagon may relate to today's American automobile, especially because the attitudes have remained, more or less, constant. Direct relationships between the Homestead Act and the fine arts are less easy to discover. However indirect connections may abound. Concurrent with the inauguration of the Homestead Acts were the Land Grant Acts that established universities throughout the Midwest: These schools generally started out with schools of agriculture and courses in home economics—the two subjects that were of the greatest interest for the new settlers. Later on (though still in the nineteenth century) art departments opened up and were then, as now, thought of as frills, whipped cream. The home economics departments prospered because they changed with the times. Recently, when it became apparent that training women to be housewives was an exploitative and sexist pursuit, the home economics departments shifted their concern to improving the style and quality of life. On the other hand, the art departments have stubbornly stuck to their elitest and obsolete principles, having swallowed their own propaganda about

art being eternal, or indispensable, or some such. When art departments, which until recently resembled home economics departments, recognize not only the fact that they, too, have to change, but also in what way they must change, only then will they have anything of interest to offer.

The Aesthetics
of Boeing

THAT THE VIDEO CABLE is the artistic as well as communications medium of the future seems assured in that the medium requires no material other than air waves. The program itself is weightless and takes up no space. It does not require storage and it can be shipped for free. The program does not require a wall, as a painting or print does.

Most importantly, the television set itself is an extension of architecture, as were painting, sculpture, and most recently, the cinema screen. (Prints, because of their easily distributable nature, have been heralded as a democratic breakthrough in the visual arts. However, the graphic forms may also be read as a last-ditch effort to preserve the obsolete and largely debilitating elitist principles of painterly communication.)

The new cable television medium is important because it results in a communications form that, for the first time in the visual area, is not dependent upon monumental or nonportable architecture.

In seeking precedents to justify the above claim, let us look briefly at the incubation periods for the several major visual media as they are found in Western culture. Perhaps a glance at certain significant innovations in the history of art may serve to focus more clearly upon the meaning and implications of the new televideo phenomenon and the art of telemaking that it requires.

The first major event in the history of modern visual communica-

tion, according to Western tradition, occurred in ancient Greece. It was linked to philosophical and political change and is illustrated, primarily, by the archaic Kouros and Kore manifestations. These indicate an appeal to a new visual attitude—one that introduced the mechanics of the displacement of space as an intelligible, abstract, high-potency visual language. It was the result of the dissatisfaction with the communicative potential of architecture. Up until then, the language of the displacement of space had been, at least partially, obscured by the domination of the architectural morphology.

What actually happened was this. Within the area of sophisticated visual communication, the importance of the archaic Greek investigations of the displacement of space as a workable communicative system lies in the fact that the sculptures, in order for them to exist, were moved away from the wall. Previously large-scale works, which significantly displaced space, were flat against the wall or actually part of the wall. Numerous examples of architectural sculpture in Egypt demonstrate this. Thus a new medium, represented by the archaic statue, is born, and mainly it is an exercise in visual and nonvisual communication. (I say nonvisual because displacement of space is not something one can see. Displaced space, in fact, ceases to exist—it's been displaced—therefore it must be nonvisual. The archaic statue employs visual elements like stone to illustrate essentially abstract or nonvisual concepts. Virtually all significant visual systems illustrate nonvisual concepts with visual materials. We are forced to conclude that visual communication is not necessarily visual at all. It does not have to be seen to be read.[1])

Architecture, the mother of all visual forms, is, on the other hand, exactly what it appears to be. It alone illustrates what it is. Unlike sculpture it does not *displace* space: it encloses it. Thus, the statue having been moved away from the wall, it became possible to perceive the essential nonvisual elements—they having been liberated from the tyranny of an architectural heritage. The tyranny of architecture lies in the monumentality and immovability of architecture. The new statue entered the realm of movable, transportable, and private objectification. It became a vehicle for the transportation

[1] See Les Levine's film *Blank: A Film for the Blind* (1970).

of communicative abstractions. One result was that the authority of the architectural enclosure was now subject to provocation. Contemporary man and his environment still feel the effects from this archaic innovation.

Before identifying the second major breakthrough in our visual-nonvisual morphology, let's consider one more point. The archaic Kouros, made to be seen primarily from the front, was a pattern for later visual explorations, both within the discipline and without. Thus it seems reasonable that they too be made with a front and a back. Since the discovery of the back, it has played a very important role in virtually all visual/nonvisual communications.

The relatively new form of painting was successful in separating itself from its tyrannical heritage, too. Its parentage was also architectural—fresco and mosaic art. Painting existed and was able to initiate a new communicative scheme when it claimed the back side. Thus the form liberated itself from complete dependence upon the totalitarian authority of architectural form. At that point flat pictorial illustration ceased to be simply a passive idiom within the sphere of architectural decoration, unable to serve the progressive medieval sensibility.

Thus we come to our second major event and the birth of a new medium that displays characteristics somewhat similar to the first. And once again the appearance coincided with major social and economic revolutions.

In Siena and Florence, in the Duecento, the movable painting came into its own. The new surface was not the same as the surface of the fresco or mosaic work because it had its own edges and therefore a back side. The new surface was a portable surface, the new form was an independent object. It was movable even though it may not necessarily have been moved. (Movability doesn't necessarily mean movement as transportation doesn't necessarily mean going anyplace.)

The painting—the new art—was unique because it was independent. It had a back side, determined precisely because the thing was portable. The point here is that nonportable things don't have backs—only vital communication phenomena are portable. Their origins were generally immovable forms.

Thus portability is an essential lineament in the identification of communicative forms: it plays an important part in the distribution of visual communicative energy. All the most vital communicative phenomena are portable. Their origins were generally immovable forms.

Thus, in all visual-nonvisual communication two factors are of importance. They are namely portability and, of course, privacy. One allows for the other. Yet, as we shall see, privacy is an anti-social condition. However, under certain circumstances, it becomes social. Portability is to service, disposability, and distribution what privacy is to dignity, sanity, and individuality. Active art requires both.

The culmination of painting and sculpture as viable communicative forms coincides with their becoming integrated into contemporary distribution systems that see art as distribution and thus, transportation. The object that best represents the fusion and de-fusion of painting, and sculpture, is the jet airplane—the typical Boeing 707, 727, 737, and 747, for example. Or, just as typically, the Douglas DC8, 9, or 10—or the Concorde, to name only a few. These objects are designed in much the same way as were the sculptural programs of typical Gothic cathedrals, or other medieval public systems. However there are significant differences. The contemporary design program—the way the airplane is painted on the outside—coincides with and emphasizes the portability of the airplane—hence the horizontal is emphasized, as opposed to the vertical. The vertical thus suggests monumentality while the horizontal is a metaphor for transportation. Trains, buses, cars, as well as airplanes bear painted stripes. The stripe is, in effect, a contemporary crucifixion symbol.

Although the plane and its design program can be read as an effort to integrate both the spiritual and architectural humanisms, they are only temporary. At least two airlines no longer paint stripes on their planes—Northeast and Hughes Air West. More will follow. The reason, obviously, is that people rarely see the airplane they are traveling in. In fact they can hardly see any planes at all at new airports. Their visual importance has diminished. We are awaiting a new visual system that will be portable, that will have both a visible front and back, that will travel through air, that will be

liberated from architecture and the monumental, that will be related to the landscape, that will be of horizontal inclination rather than mainly vertical, and that will not be rooted to the ground.

That new form has already emerged in America and elsewhere, but in America it has caused the greatest, most profoundly revolutionary change.

In America, in the mid-nineteenth century, developments in the field of land speculation helped set the stage for a major shift in communication attitudes and reception patterns. Land deserves consideration here because it is, essentially, the same as architecture and is capable of giving birth to a communicative form. Land is also one-sided. And like architecture, it doesn't have any bottom (or back) but only a top.

In America the Homestead and land-grant acts of 1862 helped introduce major new notions that ultimately were to affect behavioral patterns and visual conceptual responses. As man moved away from the urban centers to open spaces, he took with him a novel and basically unworkable idea—that of owning a little bit of land for himself, which he was entitled to, and upon which he could do as he wished without having to consider the wishes and sensibilities of others. It was a terrible idea. It abused and debased notions of portability and privacy. It was counterprogressive.

Land is not portable. It isn't private, yet it tolerates a false and antisocial illusion of privacy. It has only one side—the top. Therefore it could never work as a sympathetic, active, new human medium. Nowadays, earth artists demonstrate the antagonism of the land. The new attitude toward land caused a lot of problems, cleverly disguised, to be sure, and it wasn't until the mid-twentieth-century that man was able to use it, together with architecture, to carve out a new communicative medium that worked. The new and yet unidentified medium represents a breakaway from the entanglement of the monumental—it is a demonumentalized medium, portable, private, and it has both a front and a back.

The nineteenth-century attitude about private land as a human right could in fact never work. It created numerous problems and contradictions that are still very much part of the mid-twentieth-century American social, environmental, and identification crises,

all of which are a direct result of the fact that the people never were able to construct an indigenous, workable, cohesive communication system.

Transportation patterns that determined the modern automotive mania, the automotive culture, the obsolete imperialism, the wars, a reinterpretation of fascism called democracy, the highway sensibility, and gasoline architecture originated with these Homestead land-grant acts.

Public trains worked out all right when people lived socially, in cities, but didn't work out when they lived antisocially, in isolation. Thus public transportation was doomed and the motel invented. The whole concept of *self-service*—an anti-elitist concept that ultimately turned out to be psychologically damaging and extremely elitist—was born. To this day Americans can't bear being waited upon, and they think of service as demeaning for the servant.

The inevitable answer to the destructive nineteenth-century concepts was the private motor car and, inevitably, it was a disaster. It became, however, a metaphor for home; it was, in a sense, portable, had a top and bottom, and frequently made possible just those human contacts it more frequently denied. The car was a home: the American car doesn't transport even though it moves. Rather, it protects modern American man from crises—from attacks by savages, from the landscape he hates, and from the sensations of travel. It denies movement and actually is something of an intelligible house.

Automotive manufacturers still have not the vaguest idea of what they are peddling. They seem to know it isn't transportation. Is it a status object? Is it a landscape? A fantasy? A fetish? A security blanket? Or a house? The modern car has been sold under all these pretenses. Recent models, illustrated in the ads as if they were indeed houses, are stuck out in a nice landscape unsullied by automotive accouterments and pollution. These cars are never going anywhere. They are already there. Trains, in the days when they were advertised, were always shown going someplace, and frequently the ads included pictures of people inside the trains. In car ads the people stand next to the cars, standing on the front porch, as it were.

One response to the introduction of the car—which itself was a response to land and housing systems that were without precedent and that were doomed in every economic, social, ecological, and political sense—was a new architectural system. It introduced a sort of disposable architecture and it too was without precedent. Today architects such as Robert Venturi and historians such as Vincent Scully seek to institutionalize the new architectural scheme.

However, the new, disposable highway culture did not influence, except in certain negative ways, the architecture for housing. Domestic architecture simply regressed. In other fields, such as hotel construction, for example, there were more hopeful signs. Significant innovations in this field were linked to steamship architecture and represented a coming to terms with the realities of transportation and the obsolescence of movement. (In a thoroughly portable, disposable environment distribution is irrelevant.) The new architecture, an architecture of transportation, was symbolized in the thirties by the design and size and style of the steamship. The steamship in design, decoration, and function captured and held the imagination of the period.

Some significant architectural statements of the period were designed to suggest ships. And they were, more than likely, resort hotels in which the extraordinary phenomenon of the contemporary "cruise" was anticipated. Up until the thirties hotels in America were not the major reason for travel. They were an essential adjunct. One didn't travel just to stay at a hotel. The hotel was there, but the purpose of the journey was something other than staying at the hotel.

In the twenties and thirties resort hotels caught on. A person would travel to the hotel, stay there, and come right back home again. Thus a new concept in travel, transportation, and movement was born. Transportation/movement ceased to be an exercise involving transmission from one place to another but instead became an exercise in moving from one place *to the same place*. Nowadays the concept is still very much alive and pursued with a vengeance in the relatively new phenomenon of the cruise. Last year over half a million people boarded ships at New York City piers and took the boat right back to the same pier, where they disembarked with bag and baggage. Getting back to where they started, with all their

belongings, was the purpose of the trip. (Recently I asked an official of Cunard Lines, one of·the few companies in the business that offers both cruises and regular sailings from one place to a different place, why the company charged so much more, per passenger hour and mile, to ferry people from one place to a different place than it charges for comparable mileage when it takes people from one place to the same place. He explained: "On the transatlantic routes we are giving people more than we give them on the cruises. We are giving them transportation.")

Thus there is a completely intangible point that changes these two identical experiences into totally different experiences. May we conclude that things that don't ordinarily move may have more to do with transportation vehicles? Also, may we conclude that the potential of movement means more than actual movement?

Having prepared the reader for the last of three major events that have helped shape the visual communicative behavior of man, may I remind you that the first two, mentioned earlier in this chapter. They are the archaic Kouros and the primitive paintings of the Duecento. Both forms were created by artists who were vastly different workers from those who claim to be artists today. They were artists who were working right within the popular sensibility and imagination and nothing they came up with would ever have been called "pop art."

The third development occurred, more or less, in America (with the assistance of Japan and Germany, to be sure) in the mid-nineteen sixties. I do not refer to Minimal art or the stirrings of the conceptualist schools, though both of these artistic phenomena are, to a greater or lesser degree, results of this major shift in visual programming.

In the mid-nineteen sixties people started moving their television sets away from the wall. The implications of this phenomena, as has already been indicated, are enormous.

The discovery—an almost instinctual one that was made by a combination of explorers—was probably initiated by the Abstract Expressionist painters, whether or not they know it, whose chief contribution was that they told us that, indeed, painting was exhausted as a viable communication system. Also they added a

coup de grâce to the Sienese discovery that paintings have both front and back. They also have top and bottom to the Abstract Expressionists who, for the first time, painted the surface while it was flat on the ground. Once we learn that a painting has a top and a bottom, coming head over heels on the discovery that it has a front and back, we realize that there isn't too much else you can do with a movable flat surface, at least for the time being. The conceptualists rightly accept this challenge.

Thus by moving the television set, the major visual device of our time, away from the wall, one introduces the notion of portability to television and, in a sense, we are confronted with the transportation of television or, in other words, a new discipline that opens up an era for visual video communication that is of importance equal to that of the era of sculptural communication begun in ancient Greece (that led to the Transitional and Hellenistic periods), and that equals the innovations in the Duecento in Siena and Florence (that introduced elements of portability, in fact and concept, to the new art form known as painting). It now appears that painting is to cinema what visual-nonvisual communication is to video.

By moving the television set away from the wall one moved it away from its mother, architecture, upon which it was dependent though badly nourished, and into the realm of everyday object. The television was then thought of as an object like any other and became a more direct manifestation of the person than of his enclosure.

It became a less totalitarian medium, in effect. Also, as a personal object, it became a more private object. The parallel that immediately springs to mind is found in the development of movable-type printing, which allowed for the portable, private book, and all that implied to information distribution systems of that period. One is also reminded, at this point, of other contemporary phenomena that seem to contain some of the flexibility of portable television. Clothing (because it has an inside) such as the denim outfit is a very important one. Decorations—flags, stars, rainbows, military insignia—that are sewn on clothes are not a form of jewelry but rather have replaced the paintings that used to hang on the wall. In effect, one is hanging the paintings on one's clothes, thus on oneself. Also some types of furniture, such as file cabinets, come to

mind. They can be placed upside down and look the same as when they are rightside up. They don't require the stabilization of architecture for their identification. And then there are the obvious phenomena, stimulated by the psychedelic experience, such as body painting.

Thus television finally asserted its unique role as something distinct from architecture and, by extension, that heavily architectural medium, cinema. Long before moving the set away from the wall, we began to prepare our lives for the eventual separation.

Years ago we stopped lining our chairs up in front of the set and eating popcorn and other cinema-type refreshments marketed for consumption *in the home*—where they don't belong. Popcorn is a public confection. And, we have TV Dinners and not Movie Dinners.

In the marketing of television sets, these simple yet confusing and dramatic changes have been amply illustrated. Television advertisements no longer illustrate the set in a room with the usual interior furnishings. The latest advertisements show television sets from the back, and the focus is on the people watching the set rather than the set itself.

In conclusion, I repeat that it appears that visual media come into their own when they are set free from architecture and become instead transportation, even though they may be a form of still transportation. The tyranny of transportation itself is what we now have to contend with. That is the big problem. Ultimately, when the environment becomes totally portable, we shall find that transportation will no longer involve movement. It will serve as concept. A major result of all this, and there have been numerous indications that the result is already upon us, is a final diminishing of those critical faculties outlined by the connoisseurs—those principles of art appreciation. There will be a shift in aesthetics from attention to the art object to attention to the receiver.

Distinctive attributes of television sets, setting them apart from archaic statues and medieval paintings, lie in the realization that the sets are not themselves art objects. and that they represent a liberation of the observer from the tyranny of the object. The sets themselves do not possess aesthetic (and economic) value in their

own right, but only when they are in working order. A television set that doesn't work has no value unless it's fixed.

Thus we encounter an art object that exists only insofar as it can evoke intelligible and reasoned response, without possessing those misleading and distracting factors normally identified in traditional "art" by the dealer, the connoisseur, and the aesthetician.

The most significant threat to the supremacy to portable television as the visual medium of the modern era is, perhaps, the telephone booth. Its heritage—the sedan chair—is substantial enough to offer room for speculation. With the portability of the telephone a distinct promise, there is no reason to believe that a marriage of television and telephone will offer a new and potentially energetic medium.

Art Express

In THIS CHAPTER I should like to point out what appears to be a shift in art away from the *l'art pour l'art* idea that has dominated aesthetics. Secondly I should like to propose a new kind of art that, in fact, I believe already exists. It is an art of nontransportation, that involves transportation. Third I should like to give some examples of this kind of art—specifically airplanes and ships. And fourth I should like to show why I consider my proposals reasonable and consistent with the history of art in the European tradition.

It appears that one direct benefit from "conceptual" developments is that art has been somewhat "de-elevated." This means that art in general has been nudged closer to the world of real things. Aware of the fact that art can never be real because then it would cease to be art, I propose that it is becoming less spiritual and philosophical. Predictable calls for the discovery (elevation) of new criteria for art will result in a new connoisseurship. The new criteria will be less exclusively intellectual and "reasonable," and more a critical system of individual preference.

The new criteria will necessarily call for a new role in art for the critical concept called *taste:* today's art is unapproachable on such terms. Today's art is not a question of "liking" because it is exclusively concerned with philosophical speculation.

Taste has always been a difficult concept to define: yet it must replace philosophy as *raison d'être* for art if art is to become an

arguable phenomenon, as opposed to the ridiculous "factual," ana-
lytical, interpretative exercise that it is today. Taste is a debatable
quality. It relies upon qualitative evaluation that is both elusive and
elitist. It is assumed that an authentically nonelitist society (con-
trolled democracy) will create elitist art.

As art engages in the pursuit of de-elevation (and recent realist
art can be seen as a major step in this direction), it seems entirely
possible that much of the energy that has gone into purely aesthetic
(i.e. art) speculation will be attracted to other phenomena. What this
means is that objects, patterns, and experiences outside of art that
are regarded as primarily functional will become more deliberate
and stylish. Art's loss will be everything else's gain. Yet it should be
pointed out that art has, in the past thousand years or so, lost many
functions and come up with new ones. Such functions as portrai-
ture, historical documentation, and, now philosophy, were eventu-
ally assumed by other nonaesthetic systems. An immediate result
is that the artist will be called upon to refine the culture in broad
ways that are not exclusively artistic. Entertainment, enjoyment,
pleasure—these new nonpuritanical goals for culture will seek new
outlets.

This is not to say that art will be viewed as some kind of uplifting
phenomenon decorating an impossibly dreary environment. That is
the present, and changing, condition.

Artistic energies will be absorbed outside of art. One area for
such aesthetic speculation is transportation vehicles. There is enor-
mous potential in this more or less archaic form. Transportation
itself will cease to be essential, because all significant transportation
will involve nonphysical phenomena. On this earth the transporta-
tion of the future will be the transportation of information by elec-
tronic systems such as radio, television, etc. Transportation vehicles
approach the aesthetic as they become less essential and economi-
cally impractical. Yet they will demand a relatively old-fashioned
and "selective" response; a pick-and-choose, or "taste" aesthetic. Of
course whether one picks twiddlededum or twiddlededee may not
matter; but the element of choice and preference is there and, in art,
it is new.

As travel (transportation) itself becomes less important (if it

hasn't already, our Global Village will render travel completely unimportant sooner or later), the *means* of transportation will become more important than it is now (at least less commercial) and more important than the destination itself. If getting there is relatively pointless, the means for getting there will have to be commensurately elevated. Thus getting there will be *all* (rather than half) the fun. I am not referring to short-haul or commuter transportation but to long distance pleasure/business travel.

As a transportation vehicle the private automobile is the most damaging and least important vis-à-vis the future. It represents the past. It is already a relatively useless conveyance, and its very isolationist predilections have sealed its doom. Airplanes, trains, and ships, or some combination of all three will be vehicles employed in useless (aesthetic) travel in the future. And, of the three, the airplane appears to have the slightest potential.

Therefore it becomes especially important that these systems be preserved from extinction. The airplane is not yet threatened. The train is in a precarious position, especially in America. The transatlantic ship is in grave danger; like forests and watersheds, it requires protection. It is the art of the future. Yet it appears doomed. Therefore, as an artistic vehicle it should be treated like a painting. An art museum should purchase a transatlantic ship—preferably the T/N *Cristoforo Colombo* (or the *Caronia*), for reasons that will be explained later—and maintain it *in service*. It must remain available as a system and not as a convention center in California or a decorative arts museum in New York.

At this point several questions emerge. What are the links between art and transportation? How will transportation systems develop? In what ways are such systems already involved in artistic (i.e. cultural) programs?

Predictions concerning the future of transportation systems are vague. The confusion accompanying the development of new airplanes (like the Concorde) is evidence of a definite lack of direction for future airline travel. There is a very real possibility that airplane travel is *not* the way of the future, as it is the way for the present. Airplane travel is not secure; the airlines know it and have, willy-nilly, devised numerous ways to articulate, through visual programs, their predicament. One such "sign"—an important visual metaphor

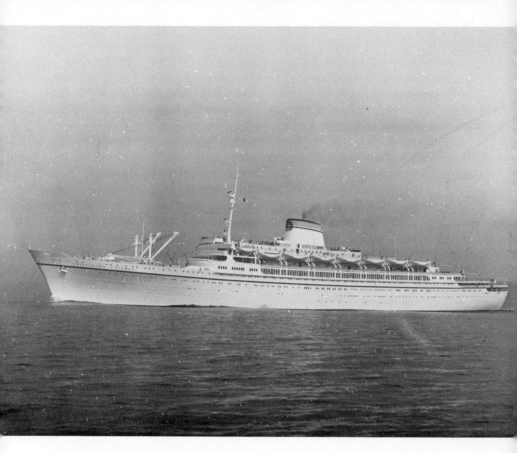

T/N *Cristoforo Colombo*. Italian Line. Constructed 1954. Photograph courtesy Italia S.p.A.N.

"Flying Colors." A DC-8 with painted decoration designed by Alexander Calder. 1973. Photograph courtesy Braniff International.

for all that flight is *not* about—is the usual stripe on the side of an airplane.

The stripe on the side of the airplane is an important human representation that is as vital to contemporary existence as was the crucifix, a useful symbol during the fifteen hundred years of Christendom. Mainly the stripe serves as a link between air travel and art, and represents the end of both as they now exist. The plane itself, which provides the surface for the stripe, is thus seen as an important art medium. A plane (airplane) is a metaphor for the transportation of people. The canvas surface exists as a vehicle for the transportation of ideas. However, both systems are essentially archaic and are at this time fusing into one another. The final goal is the introduction of new artistic patterns as opposed to flight patterns and new aesthetics rather than airports.

In fine-art terms the stripe on the plane is, perhaps, a recognition of Barnett Newman's vertical stripes. However, the airplane is horizontal and thus more modern than Newman's work. In effect, Barnett Newman was giving us airplane stripes that were incongruous because they were vertical. (Today we find ourselves in a primarily horizontal orientation, as opposed to the two thousand years of vertical orientation represented mainly by Gothic architectural technology and realized most fully in urban skyscraper technology. Airplanes are more closely related to shopping centers and cars than to skyscrapers and cities and towers. Their link with the highway is reason to interpret the stripe painted on the side as a picture of the highway. Additionally we note that airplanes are not multistoried. This is not to say that horizontal orientation is reasonable or that horizontal environmental design is workable. In fact, such orientation and design is anachronistic for our time and situation of limited resources. Because it is so obviously wrong, it requires considerable, though largely artificial, reinforcement, particularly through air travel, technology, and merchandising, which results in the emphasis on national identities. Such identities are, in fact, rapidly being obscured by the air industry.)

The stripe is read as a highway painted along the side of the airplane. It is a bold acknowledgment of the vital link between the airplane and the car. The airplane, because it requires an airport, can only work well where automobile transportation is the

main system. It must work in conjunction with the car and is a complementary system.

As soon as it becomes clear to the culture at large that cars are not desirable, that in fact they are unworkable as a communication system, we shall find the stripe disappearing from the sides of the airplanes. In fact some design firms that provide system design for airlines are already aware of this and are planning to remove the stripes. However, there is another reason that the stripe will disappear soon. As people no longer *see* airplanes they are getting into, the stripe on the side becomes pointless. Any informative or metaphorical design scheme on the airplane itself becomes pointless. However, planes will still be visible, either in the air or on the ground when seen through the windows of other planes. Therefore a new high-energy visual program will emerge, conditioned by the fact that most looking at planes will occur from within other planes. The major difference being, of course, that one will *not* see the plane one is in, but only other planes.

Such schemes have already been developed by several industry companies, the most noticeable of which is Hughes Air West with its illegible program, a nonverbal, nonreferential program, as it were.

That the airlines are deliberately and in an authentically cultural way involved in "spiritual" or at least social design statements can be demonstrated. One only has to consider the similarity between the way an airline arrives at the color, width, and position of its stripe (that it must have a stripe in the first place is not yet debatable) with the way our medieval fathers came up with the Gothic portal programs. The exterior programs for both Chartres and Pan-American were produced by teams of people mixing responsibility and effort to produce an organic, logical, and coherent whole. (We are considering here the exterior "decoration" programs, of course, and not the technology itself.) Whereas the airline logo, the windows on the plane, and the stripe are the main elements of airplane art, the medieval portal produced intrados, piers, jambs, splays, and, most importantly, the tympanum.

Just as the Gothic represents the epitome of vertical human orientation, so it conceived the first preliminary steps in today's "prone" horizontal orientation. We note the division of the tympanum into three horizontal sections rather than vertical ones, on an otherwise

almost totally vertical architectural monument. The horizontal decorative divisions must have appeared daringly new; later they were introduced into the modern architectural explorations of such Renaissance figures as Alberti, Bernini, Michelangelo, etc.

Returning to our airplanes, we note that although they are a convenient visual metaphor for contemporary behavior patterns and orientation, they do not work out quite so well as efficient transportation. In fact they may be judged antitransportation devices. Just as with American city buses, which are oversized and amazingly inefficient, the airplane industry seems to be exploiting the wrong principle, mainly that of getting people from one place to another quickly. They defy another principle—the important principle of not getting anybody anyplace at all. It is, in effect, the principle of destination and is not as farfetched as it may sound.

Perhaps one of the most incongruous remarks I have ever heard on an airplane came from a woman informed by the stewardess that the stop she was ticketed to get off at would be bypassed, due to weather conditions. "Oh it's all right. It doesn't matter where I go," she said. One *never* travels by plane without a definite destination in mind (although one can conceive of its happening in the case of a controllers' strike or an act of God). The point is that one does not, as a rule, shop around for destinations. The air industry does not offer destinations. If there is no plane going to, say, Abu Dhabi, the Air India clerk will not try to persuade you to go to Tehran instead. This represents a curious orientation to destinations and, in general, suggests that the industry will not survive new transportation concepts that serve the transportation of concept.

The most interesting and potentially most important moving system is the transatlantic ship. On a recent winter crossing of the Italian Line's T/N *Cristoforo Colombo,* passengers were advised to contact the purser if they wished to change the destinations they had originally been ticketed for. A system allowing for change in destination—in fact where such change is common—cannot become obsolete with the decline in the market for the precise destination, i.e. travel. However, it can accommodate a critical system that emphasizes the transportation itself in an inclusive way.

Thus travel becomes a likely vehicle for absorption by fine art.

The future idea of travel and what it is all about is, mainly, the functionless, uneconomic sensual/cerebral idea of art itself. Thus travel becomes important *as travel* in much the same way that art was (is) important *as art*.

The ship, already an uneconomical and apparently undesirable transportation system, encourages individual variation in a controlled environment in a way that would not be feasible or safe on airplanes. Social patterns are provoked on long-distance ship travel. Environmental control is established according to quasi-democratic patterns that soon will dominate world society. Direct yet limited encounter with natural phenomena is an integral part of the time-experience.

Because the ship is not economically viable and because it is noncompetitive with other means of transportation as a transportation system, it has a head start as an aesthetic system. Its unique arrangement and amenities place it high on a list of potentially aesthetic leisure systems. Lastly its antispeed and relatively unprogrammed behavioral outlets establish it as a forerunner of, if not a laboratory experiment in, new critical and aesthetic systems that take into consideration post-McLuhanesque behavioral demands and limitations on negative reinforcement controls that are inevitable.

The Progress
of Realism

I: SUPER REALISM

RICHARD MCLEAN makes very funny paintings, from photographs. You find a nice horse posed with one or more American middle-Western horse-folk, and the result is exactly right—in all its glory. Freaks, every one of them.

McLean's art is interesting as art because he offers *not* pictures of horses and stuff, but rather pictures of *pictures* of horses and stuff—the kind of pictures you might see in racing journals, trophy rooms of segregated, elitist country clubs in Ohio, real estate offices, businessmen's clubs, and bookie parlors.

It's all about another age, another sensibility that is beyond comprehension but that is thought of as the "enemy." It's a sensibility famous for its blandness and vulgarity, and is associated with politicians like Johnson, Nixon and Agnew, and, in general, war-mongering, conservative, loud-mouthed types who wear baggy, off-the-rack suits and narrow, stained ties. The subjects of these paintings then: vulgarity and insensitivity, of folk who completely seem to lack an appreciation of their own person, which has been completely sublimated in favor of the virile beast.

Mainly, it's worth noting that McLean's pictures are complex,

97

socially alert artworks and significant "counter culture" documents. Characteristic of these pictures are obvious and awkward "centering" and composition with stilted posturing of various figurative elements. The deliberate self-conscious compositioning sticks out like a sore thumb. Thus the shoddy mechanics of the subject, together with the equally shoddy culture of the objects represented, combine to give the reader a pretty sharp—in fact, devastating—painting. As painting it's good; as pictorial material it is appropriately embarrassing.

David Nunemaker: In some ways he is the most subversive; in the long run, the implications of his art are by far the most threatening to the status of cultural art in our society. He seems to be making art that demonstrates recent critical pronouncements concerning the need to de-elevate art, and to investigate possibilities of returning art to the people and to the ambiance of daily activity.

Nunemaker makes whatever art he is asked to make; he specializes in fakes. However, he is not at all beyond turning out highly original stuff, should the market demand it. It is thoroughly commercial, yet, in the final analysis, scarcely any *more* commercial than a lot of art that pretends it is somehow beyond corruption by the marketplace. That's a refreshing realization, especially when you are fed up to the teeth with artists who pretend they are above the level of common prostitution that afflicts everybody else.

If you need a little conceptual work, Nunemaker, with sophisticated good taste will 'make' one. If you need a nice Ellsworth Kelly for the dining room, or a lyrical abstraction in the den, Nunemaker will work to your requirements and, if possible, come up with a better lyrical abstraction than you would get from many Lyrical Abstractionists.

Ridiculous, you say. What's art coming to? Well, if nothing else, artists are discovering a variety of ways in which to reveal and subvert traditional aesthetic and cultural conventions that, in the long run, serve to obstruct the vision of man and impede his development. Such endeavors are a legitimate function for today's artist engaged in the broadening of, and appreciation for, the visual sensibility.

II: PORTER, KACERE

ONE GAME artists never get tired of playing is that of reality versus appearance. As the philosophers have pointed out, the two are not the same thing.

The dichotomy is reaffirmed in a rather outrageous and amusing way by new artist Lilliana Porter. (At least she's new to me.) What Porter does is to construct an event that is only *partially* real. Certain factors that distinguish the real from the illusive are offered in illusory form; therein lies the paradox. For example, a piece of string will pull back canvas from the frame. The other end of the string is attached to a screw that, alas, is not real but is a silk-screened photograph.

Take another example. We find a nail protruding from a tear in the canvas surface. The tear is quite real, the nail is not. One is not quite sure sometimes, what is real and what is not, and therein lies Porter's proposition. Presumably we are not *supposed* to know what to believe. The fact that the real and the unreal events depend upon one another means that the believability of the whole proposition is up for grabs. Clearly there is a theoretical sophistication here that, perhaps, is stated a little too simply. Yet, and to the artist's credit, the awkward statements are tastefully done, and in a way that excludes unnecessary decoration and presents only facts—or lies if you want. The temptation to elaborate and exaggerate the dramatic effects of the discovery are probably considerable.

And now for a moment let us toy with the works of John Kacere. Perhaps the point of these paintings is to remind art critics that they spend too much time boring everybody to death with art theory, although it is time to consider the subject of art. There is no mystery concerning the subjects of Kacere's fine paintings. They are right in front of you, and either you like them or you don't. Or, I suppose, you can do both, i.e. like the paintings but *not* like the

John Kacere: *Beth II*. 1972. Oil on canvas. 51" x 86". Collection of Carlo Bilotti. Photograph courtesy O. K. Harris Gallery, New York.

subjects. Or you can like the subjects and not like the paintings, though that would be a little silly.

I have spoken to a lot of people who are not deeply into feminine buns but, to a man, they have expressed admiration for the pictures themselves. One thing Kacere has accomplished is that he has created an art that the masses can like. The O. K. Harris gallery, where the works were exhibited, is at street level, and Kacere's show attracted a disproportionate number of local loiterers, Puerto Rican youths, and suburban couples, which I suppose is all to the good.

Kacere's paintings are, of course, exaggerations. In fact, that is part of their charm. His very oversized photographic representations of peek-a-boo posteriors is, if nothing else, amusing, especially to the people who are comfortable with high art and art history. It should be pointed out that the works recall, in scale and detail, early works from Harold Stevenson, not to mention the familiar nudes of Tom Wesselmann. Lastly, it would be wrong to ignore the broad psychoanalytic implications of these works; however, this writer is not prepared to deal with them. Let's just say that these are happy paintings very professionally, slickly produced, and that is something to be thankful for in today's overly serious New York art marketplace, in which anything that's badly done is great art.

III

ONE EXHIBITION that has singularly bridged the gap between art and the popular imagination was produced by Judy Levy and Adrienne Landau at Hundred Acres gallery, 1973. The problem is that many art people don't consider it art; in fact, most of the publicity about the show appeared in non-art places like commercial television and the society page of *The New York Times*. It was ignored on the art page.

It is not, to be sure, the first art show to effectively introduce a very sophisticated concept that, at the same time, easily engages the popular (non-art-world) imagination. Nevertheless, it is unique in that the material displayed was not originally stimulated by

aesthetic considerations. Like some good popular music primarily
motivated by social reality instead of musical tradition, the Levy-
Landau exhibition brings to art material that is not art, if you see
what I mean.

The gallery was swarming with all sorts of people who don't
usually go to galleries. There were impatient, irritable children (far
too many), public school kids, family groups, dogs, and just people
nosing around. What they were looking at were pieces of paper
documenting the lives of the organizers, Ms. Levy and Ms. Landau.
Everything was casually pasted to the gallery walls: there were
elementary school grade report cards; childish evaluations by bored
teachers, including the negative reactions of the teachers toward
any behavior that smacked of originality; there were baby pictures,
and family portraits that featured mainly the oversized, chrome-
bedecked family car.

And there were high school "senior prom" mementos, all of them
excruciatingly embarrassing, doubly so because they did not "be-
long" on the walls of a sophisticated New York gallery. An endless
series of wedding pictures, in color of course, each depicting a
"table" at the reception. Oh, the cheap decor, the candles, the
horrible flower pieces, the awful ready-to-wear clothes!

One can only hope that the marriage ended in divorce and the
adoring couple escaped society's vicious trap. Apparently they did,
or we would not have had this exhibition of sacred family memora-
bilia happily profaned.

In a way, it's too bad the Levy-Landau display could not have
been held at the same time and place as another exhibition—a show
of family photographs from the album of Catherine Noren. Orga-
nized at The Jewish Museum by the distinguished historian and
critic Dr. Avram Kampf, this was a show of photos taken by members
of Ms. Noren's family during the past one hundred years. (Cath-
erine Noren herself is a professional photographer.) The show
provides a "classical" glimpse into the history of a European Jewish
family, but without the sharp contemporary wit offered by Levy
and Landau. Yet, certainly, the Noren show is a masterpiece in the
"art of the personal," which is as good a label as any for this in-
creasingly common exhibition subject. Because the pictures from the
Noren family are quite old and feature unfamiliar backgrounds,

they seem more "respectable" and less ridiculous. They are not quite as "close to home," so to speak, and there is not the kind of over-identification that Levy and Landau exploit. While Noren herself claims a strong identification with her family, I think Levy and Landau identify even more strongly with theirs. At any rate, Noren writes in the press release for the exhibition: "My family are the people I live with in time, the people whose lives prepare for mine, for whose lives my life prepares." I doubt that Levy and Landau would have come up with that kind of appreciation. Rather one imagines them saying: "My family is as American as a goose. They are a pretentious, hypocritical, vain lot. They adored and were exploited silly by America and her material goods."

The main point of both these exhibitions, as well as lots of other shows this season, is that the artworks are mainly documentations of the artist's own immediate past. This includes Joseph Beuys and the Conceptualists at John Gibson Gallery, as well as, though perhaps to a lesser extent, a show of badly painted, outrageously conceived tableaux from one Robert Colescott at the Spectrum Gallery.

Colescott's pictures are about America, the underlying sexual fantasies that motivate its fears and prejudices, and the fantastic distortions of American heritage represented by some of the most successful commercial enterprises of our day. Take, for example, the disgusting chains of "take-out" food shops that sell greasy, plastic, over-packaged chicken and related carbohydrates. Colescott's pictures make a travesty of the "sociology" of such restaurants. Thus one subject of Colescott's art is a vast, profitable swindle—nothing less than vulgar exploitation—that will impoverish still further the wilting sensibilities of the people. America, America. Somebody once wrote: "The way you're treating your country there won't be anything left by 2000; no wonder America needs to get to the moon quicker than anyone else. You have to find someplace to dump your garbage." Amen.

Extraordinary painted shapes, rather large with lots of feathers stuck all around, were presented by Carlos Villa at the big, new Nancy Hoffman Gallery in Soho. The works are remarkable because they are so unusual—in fact, atrocious. They are cleverly, smoothly constructed; there is a serious, well-organized "presence" to these monstrosities. They effectively combine elements like clutter and

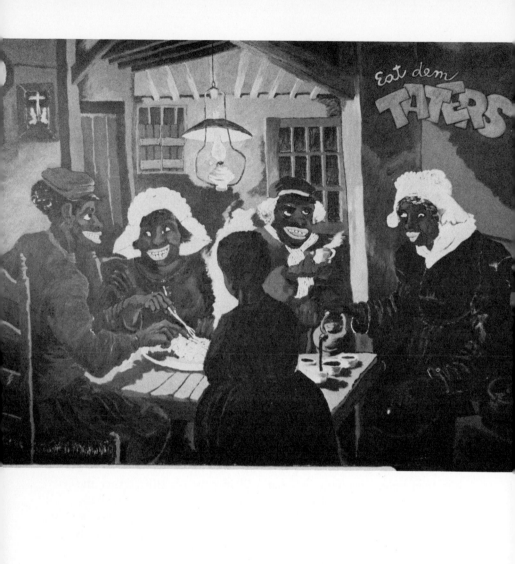

awkward shape, making use of unlikely materials such as beads, acrylic paint, feathers, and canvas. What you have is, in the final analysis, a savage work under sensitive and sensual control. You might expect a mess. You get considerable articulation and, certainly, an original choice of materials.

"Cuteness" in art, art criticism, and everything else seems to be all but unavoidable. One nice thing about much abstract art, and perhaps one reason why abstract art appeals to well-developed sensibilities, is the relative absence of "cuteness." We should be encountering, one of these days, a new art movement called "cute art." Perhaps it's upon us already. One such example of art that is nothing if not cute are Dan Flavin's new drawings of circular fluorescent lights at John Weber Gallery. The drawings actually are rows and rows of plain little circles. What did you expect? They are but one small step removed from that artist's predilection for spirituality.

IV: TWO ARTISTS REPRESENTING TWO MAJOR TRENDS IN NEW ART: A SUPER REALIST AND A PACKAGING SURREALIST

FIRST we take the Super Realist.

Elsewhere in this book we wrote about paintings by Robert Colescott that included references to fried chicken shops. We are pleased to present a representation of such a franchise by realist Ralph Goings.

This time the view of the fried chicken shop is more factual and less critical. However, sophistication provides its own criticism, and the chicken shops—highly artificial packages of highway architecture and fake Southern hospitality (both effectively pioneered and highly exploited in Middle America)—become their own severest critic. Goings offers a severe, straight-on view of things that is self-indict-

ing. A major premise of the New Realist school is that things are quite horrible as they are and there is no point in making them look worse (or better). The paintings, in fact, don't look so bad at all. They are certainly much nicer than the subjects themselves, thus affirming Penelope Gilliatt's remark "There is generally poetry in exactness."

What is a bit surprising is the serious and very real order and structure to Goings' views of apparently haphazard, familiar and tacky subjects. That structure is, of course, licensed by the picture's frame and the location of the painting itself, which is usually some refined place—a place of good taste. What would one think of this painting should it be encountered on the walls of a fried chicken store? These paintings clearly require a certain distance, not so much between the subject and viewer as between the *subject* of the painting and the *location* of the painting.

Our second artist is, to coin a phrase, a "Packaging Surrealist," which is a school that, while not yet officially identified, certainly ought to be. There are actually quite a few artists illustrating packages of one sort or another. The latest important contribution to the school comes from John Okulik, who presented large works at the new Nancy Hoffman Gallery in Soho.

The French and the Italians design the nicest packages. Americans design the ugliest, mainly because, here, it is not the package that matters but the philosophy. In America a concept, an institution, a tradition does not exist unless it can be identified and realized as a package concept. It hardly matters what these packages *look* like. What matters is the sale.

At any rate, some kinds of packages (those provided by Bravo, Christo, and Okulik, to name only three) are all the same anyway. Okulik's crates are not, of course, really crates. In fact they are more or less flat. They are travesties of crates. They are, to shorten the story, surreal packages. What is wrong is that they actually pretend to contain something. However, as if to minimize their urgency, the contents are of the same material as the packages themselves, i.e. wood shavings and bark.

The package, itself an illusion, is the thrust of these works. Packaging in art reminds us of the elevated, spiritual act of packaging, itself, in America. Here, it is acceptable to package a Nixon, but

not a McGovern. You can package capitalists but you kill Indians. You can package a war but not a peace. Packages Sell.

V

FINISHING OFF the 1972–73 season at Nancy Hoffman Gallery was an exhibition of eerie works in wood by Fumio Yoshimura. The major work in the show was an exact replica of a motorcycle, fragilely crafted and perfectly proportioned, in unfinished, soft wood. This kind of art activity recalls miniature-model building practiced by mechanically minded youths who purchase pre-fab kits that give the whole job an ordered structure. There the similarity with Yoshimura's craft ends. The major substance of the motorcycle (and the other creations in this show) is wood. As such, the disparity between the wood and the usual visual quality of a machine—the chrome, rubber, leather, etc.—is heightened. It is further heightened because Yoshimura produces his objects to exact scale. Correct scale and proportion in incorrect material is a reversal of the popular design preoccupation with distortion of both scale and material identification, in which wood is the primary victim. Dashboards in English sports cars and American sedans frequently are of plastic simulating wood. Wood is always being imitated in other materials. In Yoshimura's case the travesty is the other way around, and wood unconvincingly imitates other substances. Travesty comes into the picture because the wood is not intended to be convincing and its original identity is retained.

Yoshimura is clearly a gifted craftsman as well as a Super Realist artist. Yet his realism is fragile; it doesn't have the clout one associates with mainstream New Realism. Take Frank Crysky, for example, who exhibited big realist paintings at Warren Benedek. The oversized pictures of American Indians or Masai warriors have all the pictorial boldness one associates with New Realist art, yet they are not, by any stretch, the sort of critical, cultural documents that lend themselves to the social interpretations that characterize the

school. Rather, they are primarily sympathetic portraits, honoring
their subjects through the means of photographic composition and
the aesthetics of a slick, commercial art direction. Crysky, rather
than exploiting his subjects, cleverly exploits exaggerated scale and
soupy Kodachrome coloring.

VI: MISS SUBWAYS

THE "MISS SUBWAYS" CONTEST is not, as everybody knows, a contest.
It is, in fact, a public relations scheme dreamed up by the company
that handles the subway advertising. It is an offensive promotion,
very corny and embarrassingly sexist. It's intriguing because the
whole thing seems more appropriate for some place like Bean-
blossom, Indiana, where they don't have subways, than for New
York. "Miss Subways" is fascinating, because the main reason for
bringing all the plain-Jane Miss Subways to public attention is that
they are the lowest common denominator. They don't detract from
the ads. They are meaningless and totally uninteresting. Thus the
transit advertising company lets its customers know exactly where
they are, which is noplace.

Every month or so some 10,000 advertising placards, entitled
"Meet Miss Subways" are put up in the ad slots in the cars. A photo-
graph of a dutiful, conventional, bland, wholesome type, identified
as a secretary or in some other appropriately servile job, appears on
the card. There is a bit of cutesy copy, all about how "Jo-Anne
Marblehead" lives in the city and has only one ambition in life,
which is, always, to be a model! There have been a few changes
through the year, in design and format, but basically the thing has
remained remarkably consistent. It is really quite extraordinary that
something so totally boring—so completely stupid—could survive
almost indefinitely. And it is even more surprising, when you think
of it, that no artist has ever worked with this phenomenon till now.
(Leonard Bernstein and Jerome Robbins, to be sure, made a musical
play on the subject a long time ago, called *On The Town*. It re-

mains an important contribution to the history of the American musical comedy.)

And now, at Hundred Acres gallery in Soho, Judy Altman has documented the "Miss Subways" tragedy. There are real "Miss Subways" posters and follow-up material about some of the real Miss Subways, and that's funny because it's so very hard to think that we are dealing with real people. Actually we aren't, because, even with Judy Altman's documentation, they seem pretty remote. On the gallery walls, along with the actual poster cards, are personal letters, colored Polaroid pictures, and all kinds of curious information concerning the "Miss Subways" travesty. Most people would insist that this kind of display simply isn't art. Unlike some of the displays of documentation by conceptual artists, this show may appear too didactic—simply a history of advertising—but it certainly is intriguing and seems entirely appropriate in an art gallery. Most important, it calls attention to a unique visual/cultural phenomenon that has been sticking out like a sore thumb for years. There are very urgent lessons in this sort of factual presentation, and they involve broad cultural and sociological phenomena and touch on the behavioral and psychological sciences.

Speaking of travesty, there's Ed Paschke's new show—at the same gallery—of gaudy, ugly figures that simply go beyond the bounds of good taste. The pictures, hanging at Hundred Acres, are perfectly hideous transvestites and impersonators in the tradition of Mario Montez, Candy Darling, and Jackie Curtis. There is almost no painterly precedent for this kind of thing, unless you want to consider such "mainstream" art as De Kooning's "Women" or some of Lindner's authoritarian images. Some would view the comparison as sacrilege.

Paschke's paintings are in those Day-glo colors that graffiti vandals like to spray on subway cars. These are remarkably unattractive paintings that are appealing because they stand squarely upon their ugliness without compromise. And that's why they are brilliant. The defiance, lack of equivocation, the sheer affrontery of the works is very stylish. They are quite disgusting, very chic, and very nice paintings.

Speaking of *chic*, consider Mel Ramos' new paintings and drawings at Louis Meisel. Ramos has been around for years and, when

you think of it, you might have to credit him as one of the very first New Realist artists. Of course back then it was called "pop art." Anyway, his new paintings of super-modern, sexy, centerfold-type women are certainly charming. There they are, and you know what he's done now? He's got all these super-sexy stereotypes posed as famous artists Ingres and David and Manet might have done, and it's a scream. It's also an insult to middle-class sensibilities that have learned to respect or, rather, worship nineteenth-century interpretations of pornography, and that's funny too.

Of course Ramos is poking fun at art history. At the same time he is illustrating the element of *taste* in art judgment. What is automatically attractive at one time to one man (or woman) need not be so desirable and lovely under different circumstances. By putting his semi-pornographic figures in traditional contexts, he seems to have violated various rules in aesthetics and criticism. This is serious business, and there is no point in dismissing Ramos' paintings as some sort of historical prank.

The nude male in some of the pictures is a self-portrait of Ramos. And that ought to stop the feminists who decry his exploitation of sexy female imagery. Some viewers are said to have found Ramos sexier than his models.

VII: RECENT DEVELOPMENTS

NEW YORK CITY claims to be the biggest, liveliest, richest, and most varied art scene in the world. It is the only true center for art in America, and original artistic sparks that appear in other American cities either fit into the New York *mainstream* or they quickly disappear.

The sheer quantity of art exhibited in New York is astonishing. What is also remarkable is that so much of it is so good, though very little, in all probability, is important or good enough to earn a lasting place in the commercial art marketplace (the history of

art). Yet that kind of lasting quality is not necessarily the most
important quality in all art situations.

With so much new art (at least twenty-five big, serious com-
mercial galleries and twenty-five more that would, if located in
any other city, be considered *major*) one finds overlapping schools,
a perpetual scramble to be first in emerging trends, and a concen-
tration of related art activities that combine to insure the variety
and complexity everybody likes.

SUPER REALISM

Though the school has some of the very best artists of the day,
it does not dominate the art scene in the way that one would have
thought a couple of years ago. It is as though the struggle, the
controversy, in Super Realism simply became absorbed by the art
establishment, and Super Realist art was left without the kind of
controversy, the kind of friction and determined, emotional opposi-
tion that has helped so many other art movements to succeed.

In short, Super Realist art in New York has become accepted
and established. Rather than an either-or situation, in which one
has to choose between post-minimalist and lyrical abstraction work
on one hand, and Super Realism on the other, we have a situation
in which the two have been smoothly absorbed into the aesthetic
mainstream.

At the same time, Super Realism has shown itself to be a vital
and adaptive art movement. Malcolm Morley has moved on to
an increasingly complex and abstracted type of figuration. Another
Super Realist, William Hanley, recently showed works of complex
philosophical and aesthetic content. The paintings were of prints
of paintings, yet there were further *mirror image* complications to
the representations. Other objects played interference with the
views, and prints were placed on top of prints.

The confusion of Hanley's work is meaningful and to the point.
A fragment of a Caravaggio print, folded with visible wrinkles,
rests upon a surface; on top of that, and partially obscuring it, is a
pretzel. The pretzel provides an indication of scale. Then, on top
of these we see a painted tray. It should be pointed out that the

choice of a tray is important, because it is a flat object like the print and like the painting (the Caravaggio) the print refers to.

On top of all this we find yet another print, a still life. Although the appearance of an object among the flat-surfaced prints provides an illusion of depth (besides indicating scale), the subject of the painting is confined to two-dimensional objects. The picture is a picture because of the depth; the painting is an aesthetic object because it is about flat subjects.

VIII: SAARI, HERSHMAN, OPPENHEIM

SOME PEOPLE would say that of the three artists discussed here, no one is really an artist—at least not a serious artist. None of the three seems particularly concerned with aesthetic problems. Rather all deal, each in a different way, with broad issues that are linked to nonart disciplines and conditions. In other words these artists offer art that is concerned less with the history of art than with the investigation of problems that originate in the social, industrial, and literary fields.

Their recusancy lies in the fact that they have chosen subject matter over art.

In this way our three artists differ markedly from mainstream twentieth-century artists who, by and large, were devoted to the continual series of aesthetic rebellions, the periodic aesthetic revolutions (depending and thriving one upon the other) that characterize art of this century. Peter Saari, Dennis Oppenheim, and Lynn Hershman make art that seems to ignore the prevailing aesthetic climate. Thus they do not fit into critical movements, they consider themselves beyond aesthetic categorization, and even beyond art, as we know it right now. This is not to say their work is good because it can't be classified. Rather, their work is good *in spite of the fact* that it cannot be classified.

Nor are these three alone. For perhaps the first time in many decades an important body of artists works outside movements. Yet,

in order to do so the artists must reject at least one aspect of current art; they reject the usual rejection of subject matter. As we know, *art* is firstly about *art*. And now we find that there is a chance that art may be about other things. Subject matter is emerging to claim a positive place in aesthetics: to claim a life of its own, distinct from its forms. It is heresy.

As new artists seem to introduce emphasis to their subject matter, they protest the very idea of subject matter, and ridicule its significance. Yet the counterrevolution has begun. A two-hundred-year history of art movements seems to have lost its momentum, opening the way, perhaps, for the first authentic revolution in modern art. The revolution is the *refusal to revolt.*

This is not to say that there has been an abrupt about-face, and that aesthetics have been totally rejected in favor of story-telling. Rather we detect a shift in emphasis concerning subject matter. For example, consider the recent works by Peter Saari, exhibiting at LaMagna Gallery, New York.

Saari offers paintings that resemble, for all the world, antique fresco fragments, exactly as they are installed in a provincial museum in Crete or Rhodes. There is an archaic "stele," a corner fresco in the Pompeian style, a mosaic fragment. Photo Realism is the wrong term to use to describe these works. The emphasis is on surface, of course. Yet the museumlike details of the display demand the viewer's attention in a way that goes beyond the mere presence of an art object. There is an element of story-telling. There is theatre. There is archaeology. It is Saari's treatment of his subject matter that makes his works particularly provocative.

Consider the art of Lynn Hershman: a suite of rooms at the chic Hotel Plaza on Fifth Avenue; another suite at the seedy, arty, Chelsea Hotel downtown. The Plaza suite, its door open, had a lived-in look, as though the family in residence had just stepped out. Unfinished room-service carts, newspapers, clothing, children's games were strewed around. All the lights were on, and the only slightly unnerving touches were the plaster mannequin floating in the bathtub and a plastic arm sticking out of a rumpled bed.

At the Chelsea Hotel, Hershman offered a similar ambiance. Somebody seemed to be living in the rooms, though there were so many art lovers crowding into the place that it was difficult to

Lynn Hershman: *Chelsea*. 1975. Mixed media.

know for sure. Both hotel exhibitions remained open for a month. And what was there to admire about these works? How do the principles of connoisseurship come into play? In the main you admired the naturalness of the hotel rooms. You wondered why Hershman was going to all this trouble and expense. You wondered what all the other people crowding around were thinking. You wondered what the hotel management had to say and you wondered about the furniture, the room-service menu on the table, the framed prints on the walls, the left-over breakfast, the frayed carpeting, and how much the very idea of a hotel room resembled a microcosm of the habitat. An artificial, superficial, temporary residence; a substitute for living and living space. A subject for aesthetic speculation.

In the end the viewer concentrated *not* upon aesthetic principles or the artistic characteristics identifying the work as art but, rather, upon the subject matter (i.e. the hotel rooms) and its relationship to nonart experience. Though Hershman's works were aesthetic decisions, and though they involved sophisticated problems of discrimination, taste, judgment, and humor, they were also hotel rooms, artifacts produced by the hotel industry and designed for commercial exploitation. The country that brought you self service, Holiday Inn packages, and McDonald hamburger joints has now removed such monsters to the field of art, where, perhaps, one day they will be nicely buried.

Dennis Oppenheim's exhibition at John Gibson Gallery in New York was said to be about certain types of horrors that typify contemporary existence. It was a tense exhibition introducing lots of mystery and with an underlying touch of doom. One piece called "Echo" involved four sync-loop film projectors and extended speakers. The exhibition throwaway said: "A huge room is filled at intervals with the image of a hand slapping the wall onto which it is projected, accompanied by its sound reverberating . . . through the wall . . ."

These film images (the slapping hand) accompanied by the loud, echoing sound formed a sinister, stark, and depressing audiovisual combination that went considerably beyond the artist's in-

tention to present ". . . the phenomenon of a sound passing through a solid, a space unavailable to sight."

Another work by Oppenheim, entitled "Attempt to Raise Hell," consists of a metal "head" attached to a small, seated figure. At intervals the head suddenly lunges forward striking a huge bell suspended nearby. The sound is dreadful and the work is extremely funny and frightening. The artist explains: "The sound of metal clashing fills the room as well as the mind"—which is obvious. However, the work is more than that. Though Oppenheim doesn't like to admit it, his work is not only about itself (its aesthetic purposes), but about private, human, and speculative preoccupations.

Like most artists today, Oppenheim doesn't like the idea that his subject matter is significant all by itself. Yet the possibility keeps popping up. Today's Super Realists like to think their pictures are good because of the way they are painted, and *not* because they are interesting pictures of boats or cult Madonnas. Yet, in fact, such artists are privately thrilled by their subjects, and embarrassed by them at the same time.

IX

THE SUPER REALIST paintings of Tom Blackwell are stylistically and historically very much a part of mainstream Super Realist painting as it is practiced in New York today.

An examination of Blackwell's new paintings, exhibited at Sidney Janis gallery, 1974, reveals evidence to support the following theory about recent Realism: extreme background and extreme foreground are the key elements in Super Realism, for they produce a dialogue that frequently results in role reversal. In other words, foreground and background exchange places. Such a reversal is strictly in keeping with the painterly preoccupations of recent art.

What this means is that Super Realist painting, with all its pretension to depth illusion, is actually quite flat. The recurrent emphasis on reflective surfaces reveals a desire to make paintings that are so flat they become inside out. Today's Super Realism, it ap-

pears, is flatter than flat. It goes deeper into flatness than was heretofore thought possible. It goes to a new extreme, i.e. the greatest depth is found in the extreme foreground. Thus the foreground is a vehicle for illustration of the area *in front* of it, rather like a mirror.

The vast panes of glass and other reflective surfaces that make up the foregrounds of Blackwell's paintings serve to obscure the background while, at the same time, they reflect what is in front of the foreground. Thus what is *not* in the picture (according to formal principles of perspective) is what we see in the picture. In order to identify the dislocation the artist provides an up-close view of a wall, a curb, or a bit of sidewalk. Such fragments are the measure sticks and are the only "realistic" aspects of Super Realist pictures.

It should be pointed out that, in addition to the aesthetic metaphors described above, there is another important difference between Super Realism and previous modern art. It has to do with subject matter and the opening up of a new area for critical speculation. For example, in Blackwell's painting *Queens Boulevard* we find ourselves in the parking lot of a "drive-in" bank. Our point of view is from inside a car. The bank, surrounded by its parking lot, is an urban misfit, an architectural contradiction that art critics must, sooner or later, attempt to analyze.

X: GOOD TASTE AND
BAD TASTE IN NEW YORK

THE NATURE OF artworks exhibited by two of the four artists discussed below can be summed up in two words: *good taste*. And the subject of works by the other two can also be summed up in two words: *bad taste*.

Big, vague, figurative canvases by Grégoire Müller fall into the "good taste" category. Müller is the author of a book on Minimal and Conceptual art, *The New Avant Garde: Issues for the Art of the Seventies* (New York: Praeger Publishers, 1972), in which he con-

Tom Blackwell: *Main Street (Keene, N.H.)* 1973–1974. Oil on canvas. 96"
x 60". Photograph courtesy Sidney Janis Gallery, New York

tributes important theories that have helped provide the critical rationale for much Minimal and Idea-type art. But Grégoire Müller has firmly and decisively abandoned art criticism for painting.

Müller's first exhibition of paintings was bound to create considerable interest. And, since the paintings shown in the Deitcher Gallery bear very little relationship to his critical musings, the exhibition is surprising. No longer shacked to his theoretical positions, the critic-turned-artist refuses to practice what he once preached. As a result, the paintings represent a type of art that is quite unlike anything else that is going on in contemporary art today.

In brief, Müller has introduced a type of painting that suggests the elegance and the courteous and pleasing values associated with the very concept of "fine art." There is a conscious striving to avoid those painterly characteristics associated with struggle, conflict, controversy, and drastic innovation. The theoretical origins for this approach are to be found in Lyrical Abstraction. The ideological origins lie in the new cultural trends, which are increasingly hostile to the values of industrial society, i.e. progress and technology.

The subdued hues of brown and red and beige in these paintings —subtle, carefully wrought—are far removed from the vulgar intensities favored by recent schools of color abstraction.

Müller's paintings are composed of Matisse-like outlines of fleshy figures, elegant gestures, and vague stylistic impressions. His pictorial elements are those usually associated with the conventional principles of connoisseurship. Given art crtic Müller's penchant for predicting and explaining the very complex aesthetic developments of the late 1960s and early 1970s, one is inclined to suspect that artist Müller may be on the right track. Today there are numerous indications that the principles of formal appreciation and evaluation that favor beauty and sensual quality over aesthetic innovation and philosophical speculation have once again become acceptable. Indeed, they may even become the dominant values of serious art in the second half of this decade.

The stark, Minimalist works of Carl Andre are in very good taste because they have become classic. Andre's new floor pieces, flat

Grégoire Müller: Untitled. 1975. Acrylic on canvas. 59¼" x 145½". Photograph courtesy David Deitcher Gallery, Ltd., New York.

metal squares arranged in his usual simplified patterns of geometric architectural orientation, were exhibited at Sperone Westwater Fischer. They are exactly like his previous works and add nothing at all to what we already know about Andre's art. Yet, curiously, they do add to what we know about Minimal Art and the Minimalist aesthetic.

A Minimal artist who has arrived at an authentically Minimalist position, as Carl Andre has done, cannot, after all, add much to his work. That would contradict the major principle of Minimal Art. Nor can he take away because Minimalist theory requires that anything that *can* be taken away has already *been* taken away. Andre, the archetypical Minimalist, is primarily and necessarily a philosopher. In a way, by consistently exhibiting works that are always the same, indeed *progressively* similar, he continues to develop the theoretical principles of minimalism.

Andre demonstrates, by doing nothing new, that minimalism remains a vital aesthetic issue. One new principle comes as a surprise: if Minimal Art is to continue to develop, it must not change, either visibly or physically. Such a principle is unique among all the modern art movements and theories, and may turn out to be the major concept credited to Minimal Art.

Deliberately poor taste in art may not be new, but the type of poor taste itself changes. Take, for example, the paintings of Jerry Ott. Ott clearly knows more than simply how to be offensive and how to paint big "boobs." His paintings contain numerous references (if you can get past the vulgarisms) to advanced ideas in visual perception.

Ott's not particularly subtle realist canvases, exhibited at Meisel Gallery, contain pictures within pictures and realisms within realisms. In one of the works we see a young woman with her breasts exposed through holes cut in the front of her cheap T shirt. The design on the front of the shirt is taken from a painting by realist artist Robert Cottingham.

Another picture of a fat young woman contains a slightly raised painting of a classic MG car. Ott himself is seen sitting on the extreme foreground (bottom) edge of the picture, with his back

Carl Andre: 9 Copper Triode. 1975. Copper. 13 plates arranged as a T. 180" x 100". Photograph courtesy Sperone Westwater Fischer Inc., New York.

turned but with his head facing the viewer. Over his head is a self-portrait.

What this means is not difficult to figure out. Using pictorial imagery of decidedly aggressive and disrespectful tones, Ott highlights contemporary problems that have to do with recent developments in Realist art and philosophy.

The vulgarity of the paintings is a deliberate provocation. The rules, the format, and the order of art have been challenged repeatedly by modern artists. However, in the main, the attacks have been confined to manipulations of the materials of art, the techniques of painting, and interpretation of the subject matter. Today, a number of artists seem eager to attack the principles of art by offering obviously offensive subject matter.

Another "poor taste" artist is Stephen Varble. Varble creates extraordinary costumes, and he appears, irregularly, in public wearing them. Recently he appeared at three different Manhattan locations in one version of his poor-taste art that he himself calls "Gutter Art."

A silver Rolls-Royce pulled up to the curb. Out stepped Stephen Varble. His shaved head was colored pink and purple; his garments were zebra-striped. An air-conditioner insulator was wrapped around his middle. A steel spring with a black wig bouncing on the end of it coiled up from the top of his head. He wore platform shoes, and from his neck dangled a display board full of rhinestone jewelry.

From the trunk of the Rolls, Varble removed his props: first a sheet, which he arranged nicely in the gutter, then big floppy pillows, some dishes, pots, pans, and bottles, and a metal dish-draining rack. Reclining in the gutter among the pillows and his gear, Varble put on his elegant rubber gloves. With dignity and an air of boredom, he gracefully poured ink over everything. He scrubbed his dishes with a plastic sponge, and he looked around at the photographers. He gazed toward the heavens and then tore a hole in his stocking; he broke a dish; he looked disgusted; he mumbled to himself; he posed for the press.

Having finished with ink, dishes, pots, pans, and photographers, Varble rose from the gutter and threw some of the junk into the

Stephen Varble performing his "Gutter Art." 1975.

trunk of the Rolls. The chauffeur held the car door open as he arranged himself in the backseat. As the Rolls sped uptown, Varble peered out the back window and, almost imperceptibly, waved just once. The crowd applauded and waved good-bye to Gutter Art.

XI: NEW STAGES OF REALISM

RECENT PAINTINGS by Don Eddy (at the Nancy Hoffman Gallery, 1976), a well-known proponent of the Super Realist school of painting, reveal a logical and inevitable trend for Realism. In these paintings we find various types of highly reflective surfaces such as glass shelves, background surfaces, and polished silverware, which reflect not only one another but also fragments of the view in front of the objects. This view is not found in the painting because it is in front of the foreground of the painting. However, its presence in the picture in the form of scattered reflections is an interesting development. What is not in the picture, what is in front of the picture, becomes suggested in the picture.

Whereas the Abstract Expressionist and Minimalist schools emphasized an idea sometimes called "reduction of depth," the Super Realist school seems to have gone farther in this direction by illustrating the surface as being not merely flat but informative since it reflects what is not there.

Thus it may be said that Super Realist art reaches beyond the surface. If so, it should be recognized that Super Realist art is not merely about treating subjects almost photographically, but also involves broader problems of mainstream art.

The three artists discussed below should not be considered Super Realists in the strictest sense. However, an examination of their art reveals ideas associated with new developments in Super Realist art.

Artists working in Realist styles have revealed that the separation between so-called abstraction in art and realism is easily bridged. They imply that, in some ways, the distinction between abstraction and realism may be an empty and relatively meaningless one. Brush-

Don Eddy: *Gorevic Silver I*. 1975–1976. Acrylic on canvas. 50" x 70". Photograph courtesy Nancy Hoffman Gallery, New York.

strokes that are made the subject of paintings by Roy Lichtenstein emphasize the realistic nature of those brushstrokes. Photographic-type enlargements of Abstract Expressionist elements made by John Clem Clarke are similar in that they reveal how pictures of paintings become realistic when viewed merely as pictures of paintings.

In some new paintings by Gisela Beker at the Loeb Gallery (1976) and Malcolm Morley, two stylistically disparate artists, the concept is advanced another notch. Beker introduces, in her paintings, two normally irreconcilable elements of abstraction: the classic and geometric, on one hand, and the romantic and painterly, on the other. Such juxtapositions do not normally coexist in a single painting. In fact, it is generally felt that they simply cannot coexist since they would cancel each other out and the painting would be making less sense, either classically or romantically. However, if the goal of the painting is just that of illustrating the irreconcilable distinctions between the classic and romantic extremes, then this irreconcilability becomes the subject of the painting and thus justifiable.

Whether Beker has yet been able to make her formulation convincing is debatable. The future development of her art may prove of great interest. Nevertheless, the idea of painting a picture *of* classicism, as opposed to pictures that are classic, for example, is certainly an interesting one.

A somewhat similar problem occurs in the new works by Malcolm Morley exhibited at the Clocktower Gallery in 1976. Morley remains one of the best known artists of the Super Realist school, and he continues to lead the art style he is credited with having founded.

Morley's new realist paintings don't look realistic at all. They seem more like impressionistic and expressionistic documents. However, a close examination of these blurry, garish works reveals a changed concept of Realism in art. Morley demonstrates the fact that a painting does not have to look "realistic" in order to be a Realist work.

For example, one new painting by Morley depicts the transatlantic liner S.S. *United States,* thus recalling the artist's earlier pictures of such vessels as the *Rotterdam,* the *Cristoforo Colombo,* and the *Leonardo da Vinci.* However, there is a startling difference. The new S.S. *United States,* while resembling the early works, is painted in a completely different way. The picture seems bent and irregular.

Gisela Beker: *Mandala Sponsal.* 1976. Acrylic and oil on canvas. 36″ x 36″. Photograph courtesy Loeb Gallery, New York University.

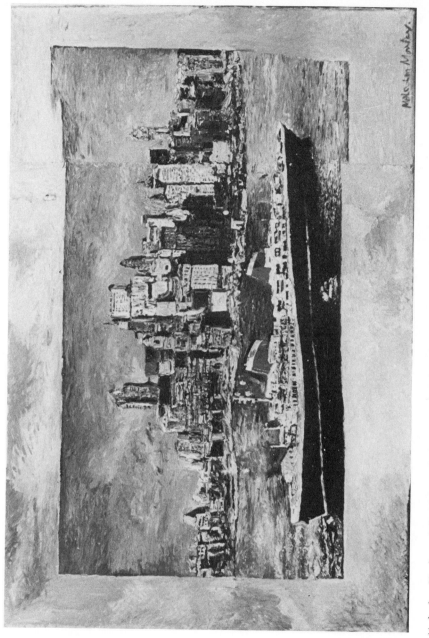

Malcolm Morley: S.S. United States. 1976. Oil on canvas 40" x 60". Private collection.

Lynn Hershman: *The Future Is Always Present*. 1976. Mirror and manne-
quin. Installation in window #11, Bonwit Teller, New York. Photograph
courtesy the artist.

Different sections seem painted from slightly different perspectives of depth and color. A wide border that seems to be painted with the same detail and thoroughness of the rest of the surface is irregular and curious.

After close examination the subject finally becomes clear. The painting is not of the S.S. *United States*. Nor is it a picture of a picture postcard of the S.S. *United States*. It is, in fact, a faithful rendering of a color Xerox copy of a picture postcard of the S.S. *United States*. The major change is one of scale.

In other new paintings Morley continues to draw upon the images he introduced years ago. But the context is new, and it is precisely the new, changed context that has become the subject matter of the new paintings. For example, a jet plane crashes into the *Rotterdam*. This is not a picture of doom and destruction but, rather, a view of changed time, changed circumstances, and changed context, all the changes identified according to the recognized, stable images of the past.

The art of Lynn Hershman, discussed elsewhere in this book, has recently moved out of the gallery and directly into public space. In this move we discover that her conceptualist-type presentations have taken a new identity by successfully presenting a type of art that hitherto has been confined to the gallery and museum. The result of the change in identity and viewing situation could well have an impact on the development of contemporary art.

At first it may appear that Ms. Hershman's new project, decorating the windows at Bonwit Teller, is old hat. In 1934 Salvador Dali also did the windows of this store, and that event has become part of the history of modern art.

Ms. Hershman's situation is different, however. It comes at a time when the major museums of modern art have become increasingly conservative, and when popular culture has become increasingly tolerant of and interested in problems of aesthetic speculation. This combining fine art with the refined art of New York shop window decoration involves a meshing of the popular and the intellectual that is apt to have broad repercussions for the further dissemination of art.

Index

Numbers printed in **boldface** type indicate illustrations.

134 *Index*